CREATURE FEATURES

CREATURE FEATURES

DRAW AMAZING MONSTERS & ALIENS

RANDY MARTINEZ

IMPACT
CINCINNATI, OHIO
www.impact-books.com

ABOUT THE AUTHOR

www.randymartinez.net

Randy Martinez was born and raised in southern California. The son of two artists, he was destined to be an artist himself. But his road to being a professional started on the basketball court at California Lutheran University. Not only was Randy on the basketball team, he also served as the official team artist, creating "Lu Dog" logos and T-shirt designs.

Eventually Randy's art professor helped him realize that his future didn't lie in a pair of sneakers. After a two-year stint at CLU, Randy spent two years in the art program at Ventura College before attending the Kansas City Art Institute. Kansas City represented a chance for Randy to get out of his comfortable setting in southern California and challenge himself with new forms of art and ideas.

After receiving a bachelor of fine arts degree in design and illustration, Randy moved back to southern California to pursue a professional art career. He got his first big break in 1999 by doing artwork for *Star Wars Kids* magazine. Since then, Randy has become a favorite among *Star Wars* fans. His art has been published and used for official *Star Wars* publications and collectibles worldwide.

Randy currently lives in southern California, where he illustrates books, children's games, trading cards and *Star Wars* memorabilia. To learn more about Randy and his art, visit www.randymartinez.net.

Other fine IMPACT Books are available from your local bookstore, art supply store or online supplier. Visit our website at www.fwmedia.com.

13 12 11 10 09 5 4 3 2 1

DISTRIBUTED IN CANADA BY FRASER DIRECT
100 Armstrong Avenue
Georgetown, Ontario, Canada L7G 5S4
Tel: (905) 877-4411

DISTRIBUTED IN THE U.K. AND EUROPE BY DAVID & CHARLES
Brunel House, Newton Abbot, Devon, TQ12 4PU, England
Tel: (+44) 1626 323200, Fax: (+44) 1626 323319
E-mail: postmaster@davidandcharles.co.uk

DISTRIBUTED IN AUSTRALIA BY CAPRICORN LINK
P.O. Box 704, S. Windsor NSW, 2756 Australia
Tel: (02) 4577-3555

Library of Congress Cataloging-in-Publication Data
Martinez, Randy.
 Creature features : draw amazing monsters & aliens /
Randy Martinez.
 p. cm.
 Includes index.
 ISBN 978-1-60061-143-8 (pbk. : alk. paper)
 1. Monsters in art. 2. Extraterrestrial beings in art. 3.
Drawing--Technique. I. Title.
 NC1764.8.M65M34 2009
 743'.87--dc22 2008042232

Edited by Erika O'Connell
Designed by Wendy Dunning
Production coordinated by Matt Wagner

METRIC CONVERSION CHART

To convert	to	multiply by
Inches	Centimeters	2.54
Centimeters	Inches	0.4
Feet	Centimeters	30.5
Centimeters	Feet	0.03
Yards	Meters	0.9
Meters	Yards	1.1

ACKNOWLEDGMENTS

I'd like to thank all the people who have helped and inspired me:

My lovely Niecie, for all of your love, for being my best friend, and for understanding what it takes to be an artist.

Mom, for believing in me and supporting who I am.

Steve Sansweet, for giving me my first break and for always thinking of me.

Matt Busch, for your friendship and for giving me confidence when I needed it most.

Jamie Gomez, for being my bro. I couldn't have survived Hollywood without you.

The late John Alvin, for your wisdom and inspiration.

Patrick Jaime, for cutting away the bad energy and bringing me peace.

Paul Wintner, my great friend and No. 1 fan.

Brian and Shelly Ehler, for always believing in me; it has made all the difference.

Alex Alderette, Rika Traxler and Bacon, for your friendship and for helping me get through school. I'll never forget the things we learned together.

Dr. Jerry Slattum, for flipping my world upside down and helping me see the light.

Richard Peterson, for tapping my potential.

Bill and Jan O'Neil, for being great friends. I still owe you one for CIV.

Mary Franklin, for your energy and smiles.

IMPACT Books, Lucasfilm Ltd., Acme Archives, Topps Trading Cards and Playroom Entertainment, for giving me work.

Finally, a special thanks to my dear friends: Susi Wong, Dov and Sara Joe Kelemer, Lawrence Noble, Matt Shell, Melissa Suther, Peter Svab, Randy Shanklin, Cara and Chris Seymore, and all the ball players at the Hollywood YMCA.

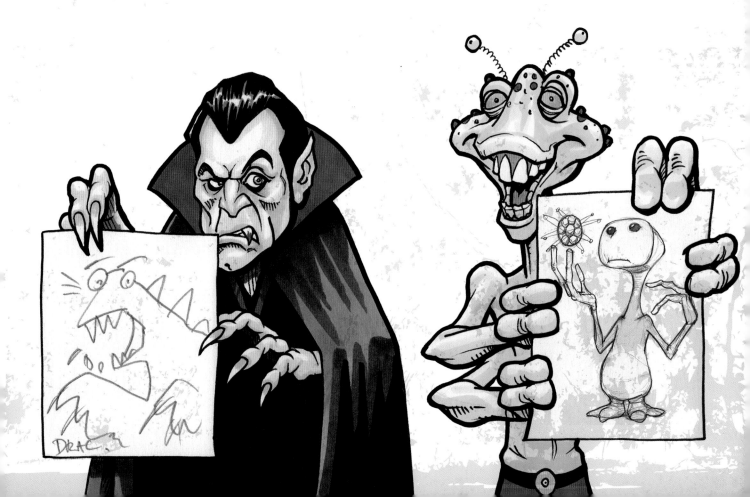

TABLE OF CONTENTS

INTRODUCTION

Monsters and aliens have been a part of my life for as long as I can remember. As a toddler, I was known to carry around a rubber shark rather than a cliché teddy bear, due to my fascination with sharks after seeing the movie *Jaws*. (Yes, I was warped at an early age.) I loved sharks because they were scary, and being scared was exhilarating to me. I wanted more.

I soon discovered classic monster movies on TV, such as *Creature From the Black Lagoon* and *The Wolf Man*. Naturally I started drawing monsters like crazy. While other kids were drawing flowers and puppies for a Mother's Day card, I was drawing a shark chomping on some poor water-skier. (That's what every mother really wants, right?)

My life changed forever when I saw *Star Wars*. That movie opened up my imagination and introduced me to the idea of aliens. And, oh, how I love the aliens in *Star Wars*! I watched TV specials and read magazines to learn how the artists came up with all of those great-looking creatures, and it inspired me to start creating my own.

As I've gotten older, I have never lost my love for monsters and aliens, and I continue to draw them today.

Monsters and aliens are important to our culture because they allow us to confront our deepest fears. Often, the monsters we find appealing are those with whom we have something in common. A person who has a short temper and becomes mean when angered might relate to a werewolf. Someone who feels different or misunderstood might identify with an alien.

Monsters and aliens also give us the freedom to use and expand our imaginations. The ability to invent new creatures helps us fill in the blanks and have fun with what we don't understand about our universe.

You could say monsters and aliens benefit us more than they could ever hurt us—at least the ones we create for entertainment.

So, have fun with this book, and remember that it's *your* imagination, *your* expression and *your* exploration that matters to your art. As long as you have fun, you can never create "bad" art!

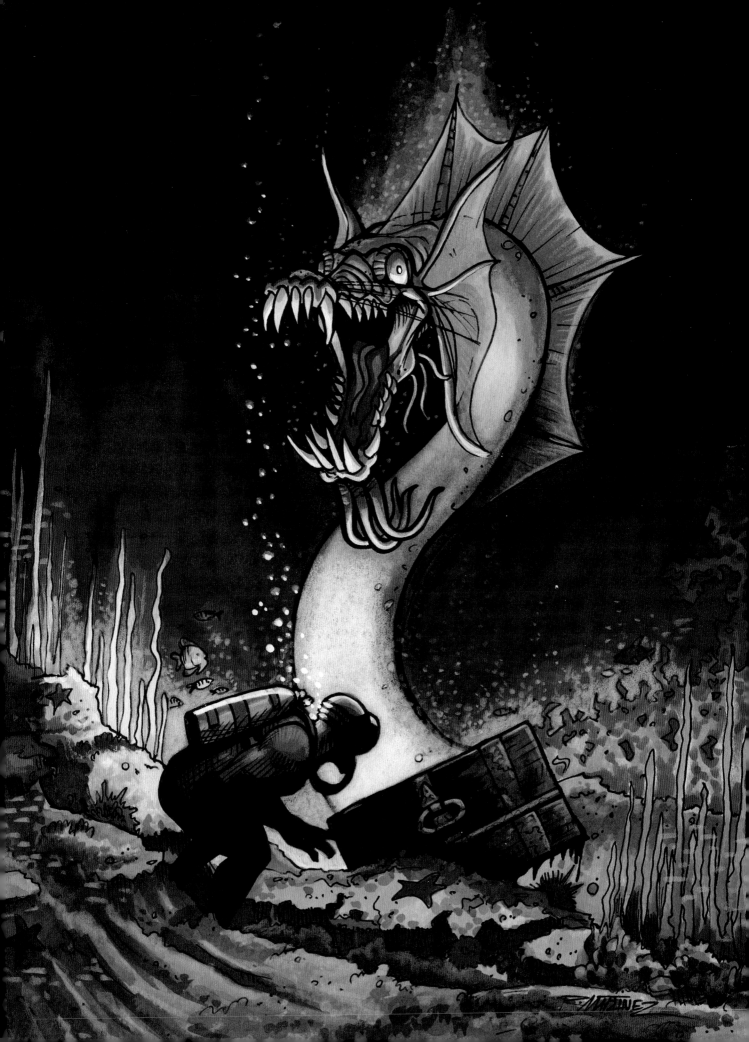

PART I

GETTING STARTED

Before you can start creating monsters and aliens, you need to have the right materials as well as some basic drawing skills. This section provides everything you need to know about art materials, including some really cool pencils, pens and other tools you may not know exist. You'll also learn some important theories behind drawing and shading. Then I'll teach you the simple techniques used to construct all the creatures in the book.

PAPER

You can use all kinds of paper for drawing. They range in price, and each has its unique purpose.

SKETCH PAPER AND DRAWING PAPER

Both kinds of paper come in tear-away pads that are fairly inexpensive and great for travel. Although quite similar, sketch paper tends to have more tooth to it, which means its surface is not as smooth.

BRISTOL BOARD AND ILLUSTRATION BOARD

Both kinds work well with pens and markers. They are similar in texture, and both have two kinds of finishes: smooth (hot press) and vellum (cold press). Hot-press boards produce sharper lines and tend to scan better. Cold-press boards have more tooth, making them ideal for use with paints or pastels. Both the front and back sides of bristol board are finished, whereas illustration board has only one finished side.

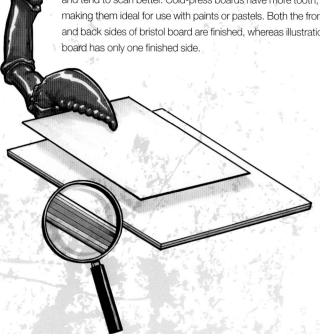

WATERCOLOR PAPER

You can use this type of paper with more than watercolor paints. It has a very cool texture that is fun to draw on with pencils.

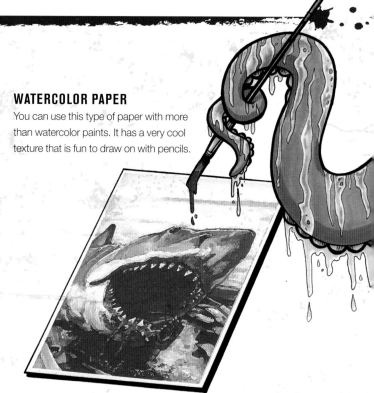

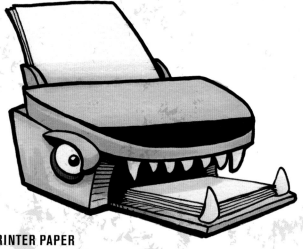

PRINTER PAPER

Yes, good old printer paper is some of the best paper for sketching. It's inexpensive and has a good texture for pencils. I use it all the time to sketch ideas before I move on to a finished piece of art on bristol or illustration board.

PENCILS AND ERASERS

Just as there are different types of paper, there are many different kinds of pencils and erasers. It's a good idea to have a variety of pencil types so you can get the desired effect for each job.

The most common pencil you will find is a **No. 2 pencil**. You probably have a few in your backpack or lying around your house because they're perfect for everyday use.

Art pencils are graded with numbers and/or letters to indicate the hardness and the blackness of the lead. The higher the number on the H side of the scale, the harder the lead and the lighter the markings. The higher the number on the B side of the scale, the softer the lead and the darker the markings. The standard No. 2 HB pencil falls right in the middle of the scale, meaning it's not too hard, not too soft. Try a few of each grade to see how they perform.

Woodless graphite pencils are unique because they're made without wood. The reason that is desirable is because when you learn to draw expressively, the pure graphite allows your hand to zip all over the page without needing to be sharpened for a while. These pencils can be somewhat messy, but they're great for filling in big dark areas.

Mechanical pencils come in many different styles and prices. Mechanicals are great because they keep a steady, thin line and require no sharpening.

A **wooden stake** can be used for…well, it's really only good for killing vampires!

Make sure you have a **pencil sharpener** unless you plan to draw with mechanicals only. Electric sharpeners are great, but hand sharpeners work just as well.

Not only do you need different pencils to create different effects, you also need a different eraser for different jobs.

A **pink eraser** is the same kind of eraser that sits atop your No. 2 pencil. It's good for general use, but it can be too rough for light erasing.

My favorite is the **gray kneaded eraser**. It can stretch, bend and pick up most pencil marks except for really dark ones. It's also soft, so it's gentle on paper.

A **gum eraser** works great with hard-lead pencils. It will crumble easily, but that's to protect the paper.

White erasers are a good alternative to the pink ones, as they are softer and less abrasive.

Eraser pens are filled with the white eraser described above, and their design allows you to be more accurate with your erasing.

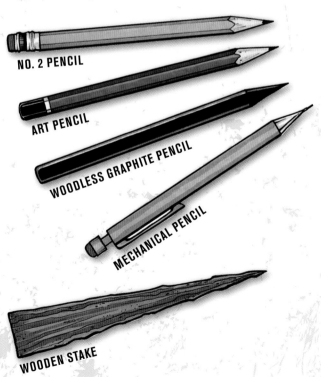

NO. 2 PENCIL

ART PENCIL

WOODLESS GRAPHITE PENCIL

MECHANICAL PENCIL

WOODEN STAKE

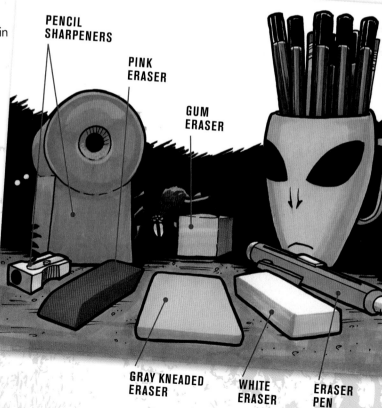

PENCIL SHARPENERS

PINK ERASER

GUM ERASER

GRAY KNEADED ERASER

WHITE ERASER

ERASER PEN

PENS AND MARKERS

Use pens and markers after you've completed all of your sketching with pencils. It's a big step because you cannot erase pen marks, so you want to be able to just trace over your pencil lines.

Brush pens are great for creating thick or thin expressive lines.

Calligraphy pens have hard chisel tips for doing—you guessed it—calligraphy. You can also use them to fill in big black areas quickly. It's interesting to draw with them, too.

Felt markers are generally used for coloring in big areas, but some are fine tipped so you can draw with them.

A **finger bone** is great for…pointing!

Technical pens are expensive because they're difficult to make. They deliver an even amount of ink in a consistent line width. They're easy to ruin if not used properly, but great for making straight lines.

Dip pens are the "old school" pens made with a nib that you dip into a bottle of ink. There are many different types of nibs; try them all to see what works best for you.

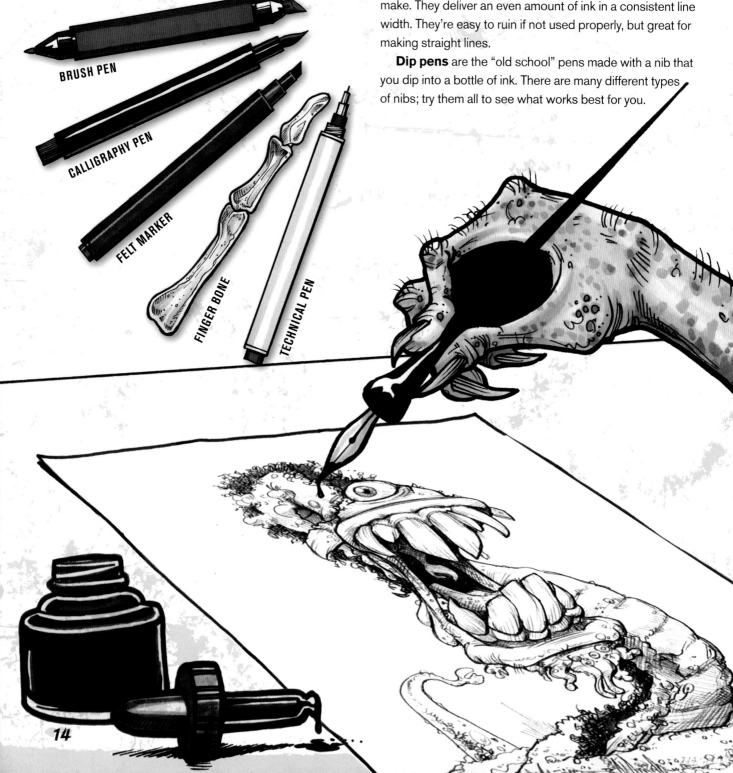

BRUSH PEN

CALLIGRAPHY PEN

FELT MARKER

FINGER BONE

TECHNICAL PEN

OTHER TOOLS

There are endless tools available to help you create straight lines, curves and a variety of shapes. They are not vital to drawing, but they can help you avoid frustration when trying to draw accurately.

Use a **compass** to draw perfect circles, and a **ruler** to create straight lines.

A **French curve** lets you draw a variety of curved lines, while a **drafting triangle** helps you create perpendicular lines.

If you don't want to create the lines and curves yourself, you can opt to use **templates** that have pre-cut stencils of circles and other shapes of all different sizes.

Try creating a variety of shapes using both methods to see what works best for you.

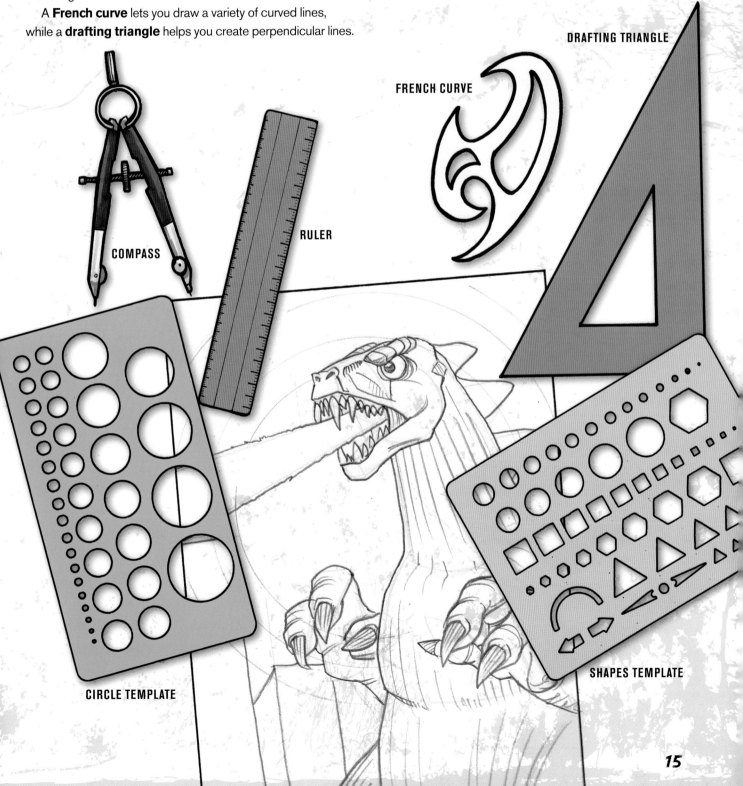

DRAFTING TRIANGLE

FRENCH CURVE

COMPASS

RULER

CIRCLE TEMPLATE

SHAPES TEMPLATE

THE WORKSPACE

Your workspace is one of the most important parts of your creative process. You should be comfortable and happy in the space, and you should have plenty of room to swing your elbows. You don't need to have the largest desk in the world, but you certainly don't want a surface that is too small for your work.

It's essential that you respect your workspace and keep it as neat and clean as possible. Organize your materials and tools so they are easily accessible yet out of your way.

Lighting is important, too. If you can't have a lamp directly over your work surface, make sure you work in a well-lit space so you can clearly see what you're doing.

Finally, be proud of your work no matter what your skill level. Don't limit your gallery space to Mom's refrigerator; hang your drawings all over!

You can learn a lot by studying your own work, so have it where you'll see it often. Plus, it's fun to watch your friends and family marvel at your artistry—not to mention their shock at how scary you actually are!

ART IS NOT A RACE

I often get asked of my work, "How long did it take you to draw that?"

It leads me to believe that many people suffer from a misconception that the faster something is drawn, the more impressive it is, or that the art is somehow better.

The truth is, it does not matter how long it takes you to create a piece of art. If you do the best work you can do at your own pace, the end will always justify the means.

BASIC SHAPES

The first thing you need to learn in order to draw well is how to see the world in very basic terms. Looking at objects as basic shapes will help you realize how simple they are to draw. Start by seeing everything as *basic* shapes—first large shapes, then smaller shapes inside those larger shapes.

SIMPLE SHAPES

A basketball is just a simple circle. A shark's tooth is a triangle. A TV is a square. Look for other things around you that can be broken down into basic shapes.

THREE-DIMENSIONAL SHAPES

Start looking for shapes that are three-dimensional. A soda can is a cylinder. A briefcase is a box. A coffin is almost a hexagon box.

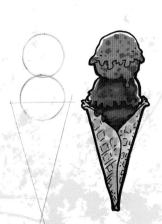 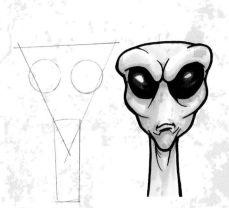 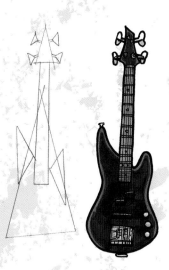

MULTIPLE SHAPES

See if you can find multiple shapes within an object—an ice cream cone, an alien or a bass guitar. There are lots of small shapes within these objects. And that's the basic secret of drawing. See how simple it is!

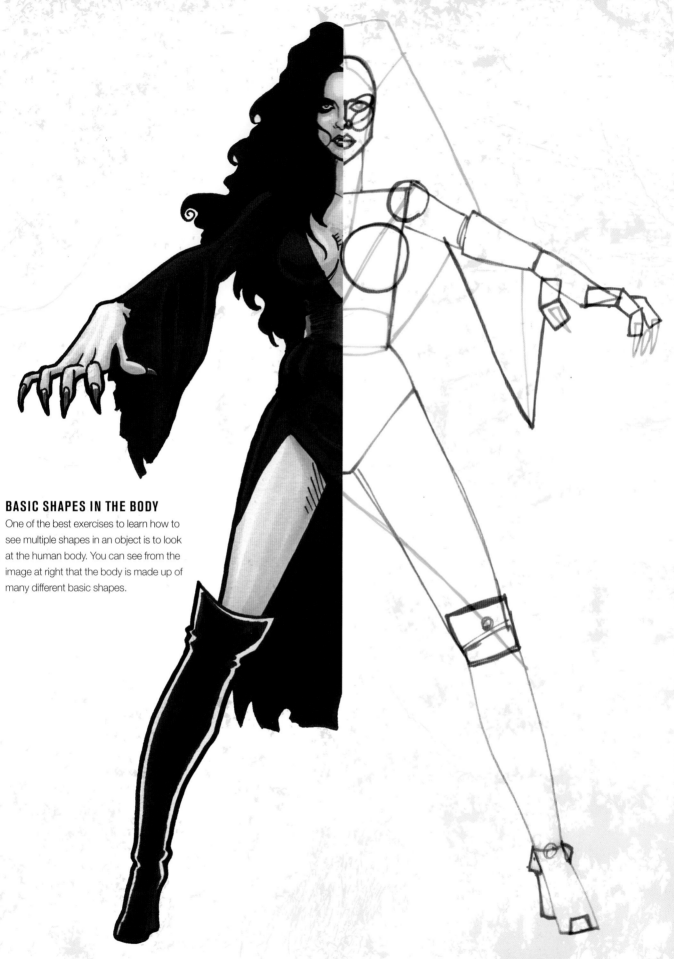

BASIC SHAPES IN THE BODY

One of the best exercises to learn how to see multiple shapes in an object is to look at the human body. You can see from the image at right that the body is made up of many different basic shapes.

THE HUMAN HEAD

Obviously monsters and aliens do not have the same head shape as humans, but when you don't have an alien or monster from which to draw, the human head is a great place to start.

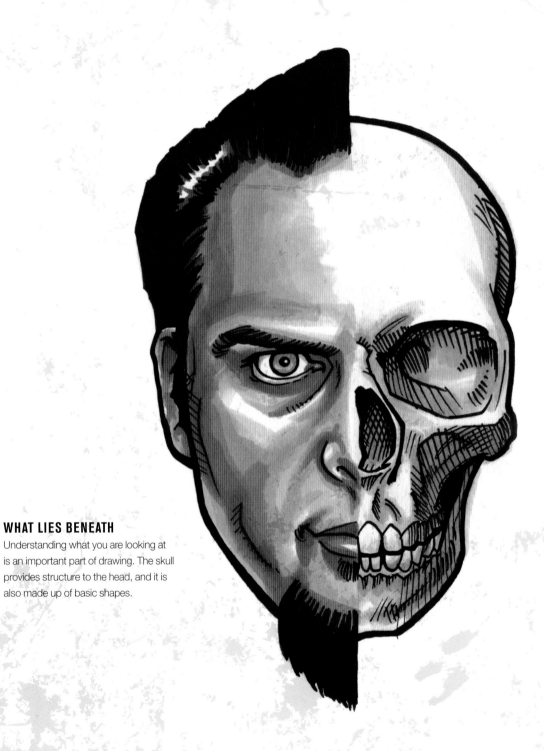

WHAT LIES BENEATH

Understanding what you are looking at is an important part of drawing. The skull provides structure to the head, and it is also made up of basic shapes.

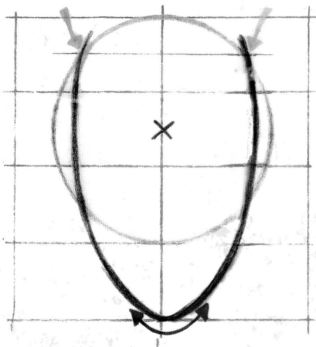

1/8
2/8
3/8
4/8
5/8
6/8
7/8

BASIC HEAD SHAPES

1 For a human head, start by drawing a square. Lightly draw a vertical line down the middle, and three equally spaced horizontal lines across to make eight sections of equal size.

2 Lightly draw a small x about $\frac{3}{8}$ down from the top of the square. With the x as your center point, draw a light circle that spans from the top of the square to the $\frac{6}{8}$ line.

3 Starting at the lower quarter, draw the bottom half of a hexagon, with the bottom width about $\frac{2}{3}$ the length of the sides.

4 Draw a light line that intersects the circle at $\frac{1}{8}$ from the top of the square. At the intersection points, draw sloping lines to connect with the half-hexagon.

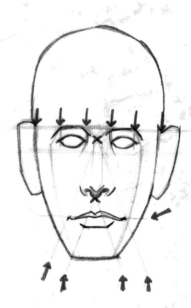

MALE FEATURES

Use different points from all of your guidelines to measure and place features on the face.

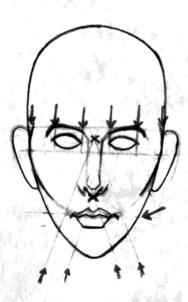

FEMALE FEATURES

Draw softer and more curved facial features on females.

FEMALES ARE DIFFERENT

Drawing the female head is basically the same as drawing the male head, except the female jawline is softer. Instead of a half-hexagon for the jaw and chin, draw a shape that looks like the narrow end of an egg.

ANIMAL SHAPES

Most monsters and aliens we see are based on human and animal features. Some, like the Wolfman and Minotaur, are half human, half animal. So it's a good idea to study animals for reference.

Monsters and aliens are scary because they remind us of things that already frighten us. But they are also scary because of what we don't know. The key to making really scary beasts is to mix features of common animals with those of exotic creatures. For example, tigers are scary, but a tiger with a rare lizard's eyes is downright freaky!

There are thousands of species of animals all around you, from insects to birds, from cats to dogs. Study them, draw them and use their basic features to invent new creatures.

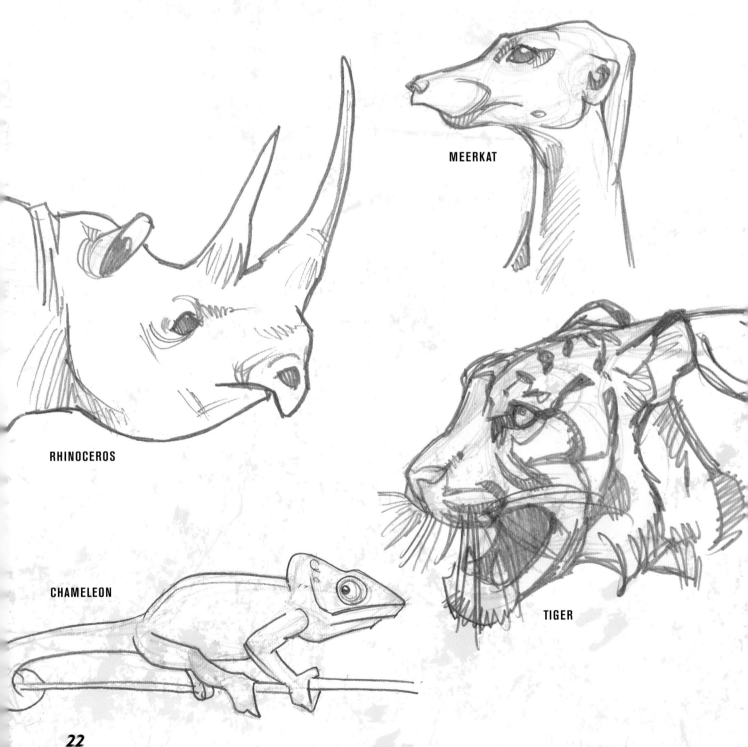

MEERKAT

RHINOCEROS

TIGER

CHAMELEON

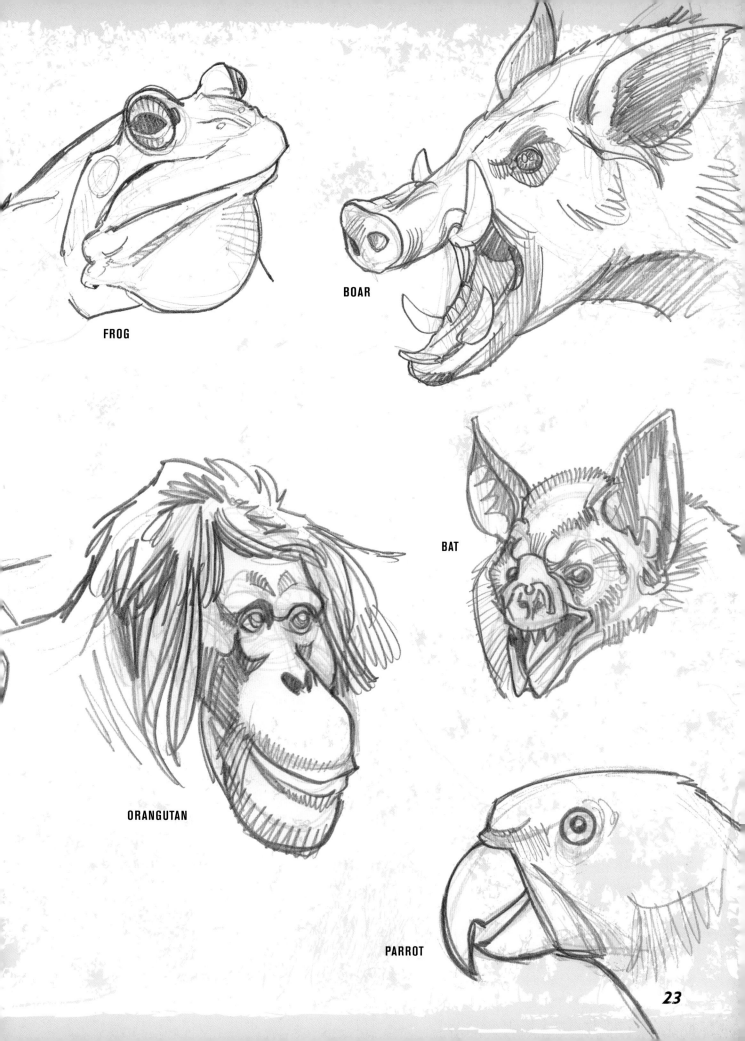

FROG

BOAR

ORANGUTAN

BAT

PARROT

PAWS AND CLAWS

No monster is complete without menacing limbs used to grab you. There are all kinds of claws, webbed feet, hands and tentacles. Again, look at many different animals for inspiration. You can even use your own hand as a model. Now that's scary!

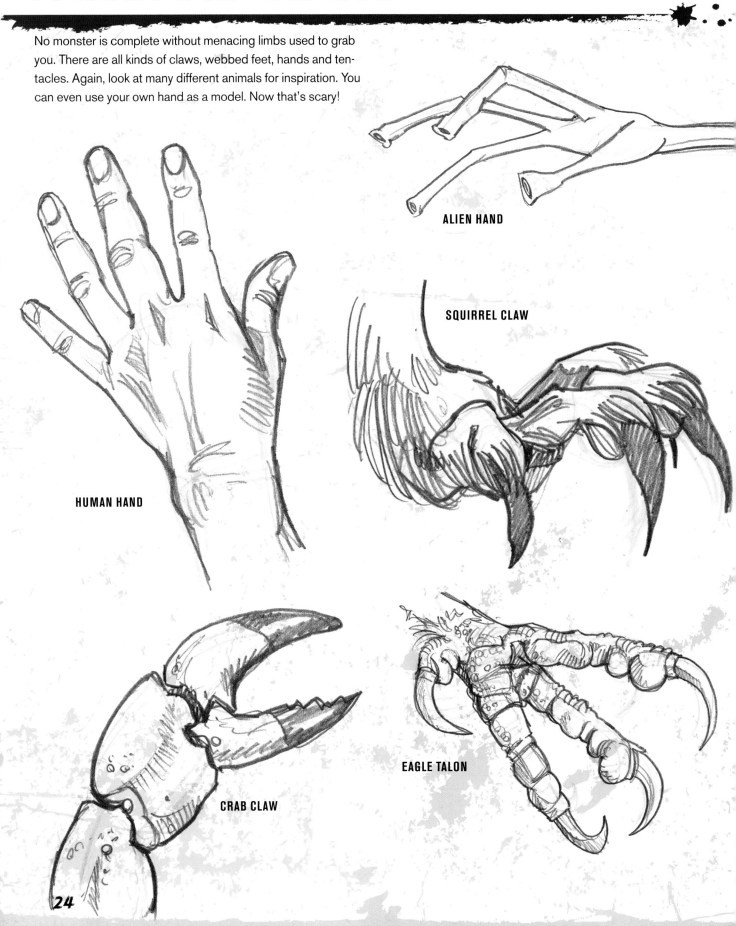

ALIEN HAND

SQUIRREL CLAW

HUMAN HAND

CRAB CLAW

EAGLE TALON

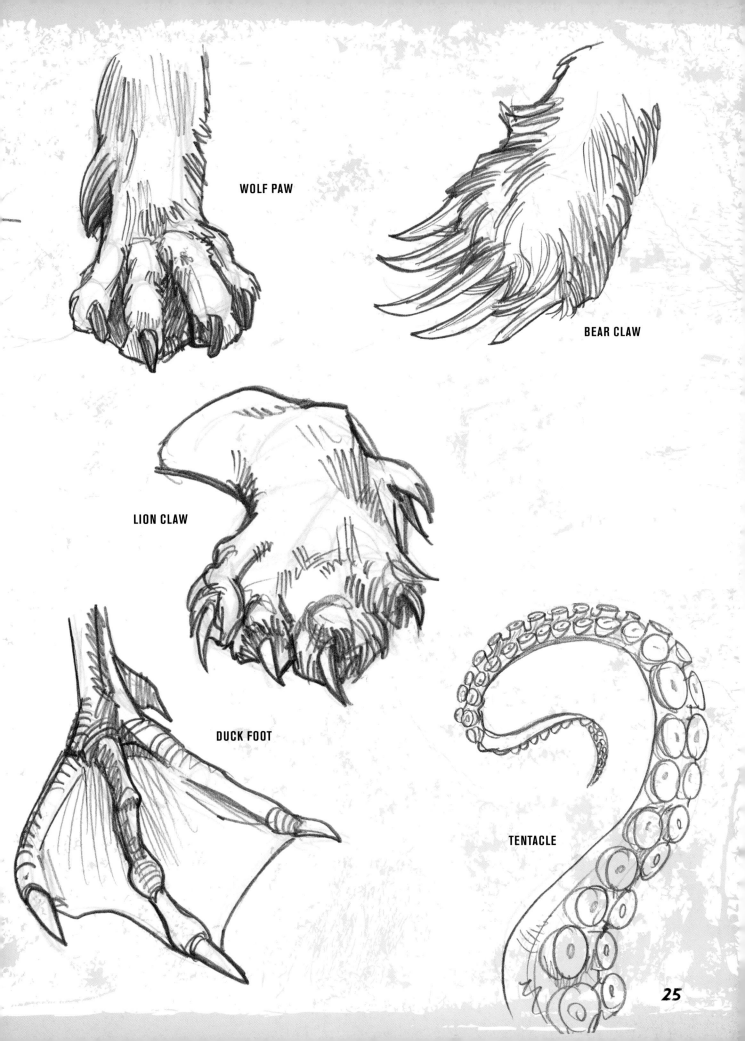

WOLF PAW

BEAR CLAW

LION CLAW

DUCK FOOT

TENTACLE

LIGHT AND SHADOWS

Now that you can draw shapes and build a drawing, you need to learn how and where to create shadows.

First, you have to understand the concept of *light source*: the direction from which the light is shining. It's important to establish this before you begin shading anything so you can place your shadows on the correct side. Shadows are always on the opposite side of the light source. They give your drawings mass and create the illusion of three dimensions.

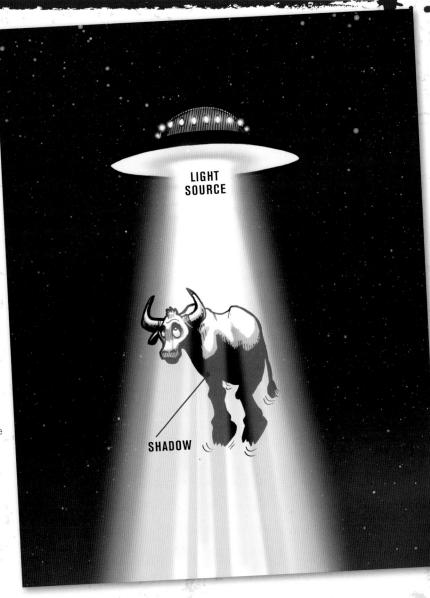

LIGHT CREATES SHADOWS

The light shining on the cow is coming from the spaceship directly above it, so the shadow is on the underside of the cow. The light is very bright, which creates more contrast between the highlights and shadows, meaning there is less gray area.

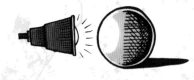
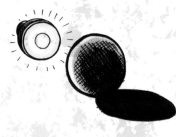

LIGHT DIRECTION

This example shows the shadows created by a light source hitting a ball from different directions. The ball with a lamp shining on it from both sides still has a shadow, but it is thin and the gradation is on the side of the ball closest to you.

SHADING TECHNIQUES

Knowing the direction of the light source is only half of the job. You also need to know how to draw shadows. There are several shading techniques, each of which creates a different effect.

SCRIBBLES can be either a combination of all of the other techniques or just quick, random scribbles. It might seem odd, but sometimes basic scribbles can create the exact effect you want, especially when drawing something as spooky as the Grim Reaper.

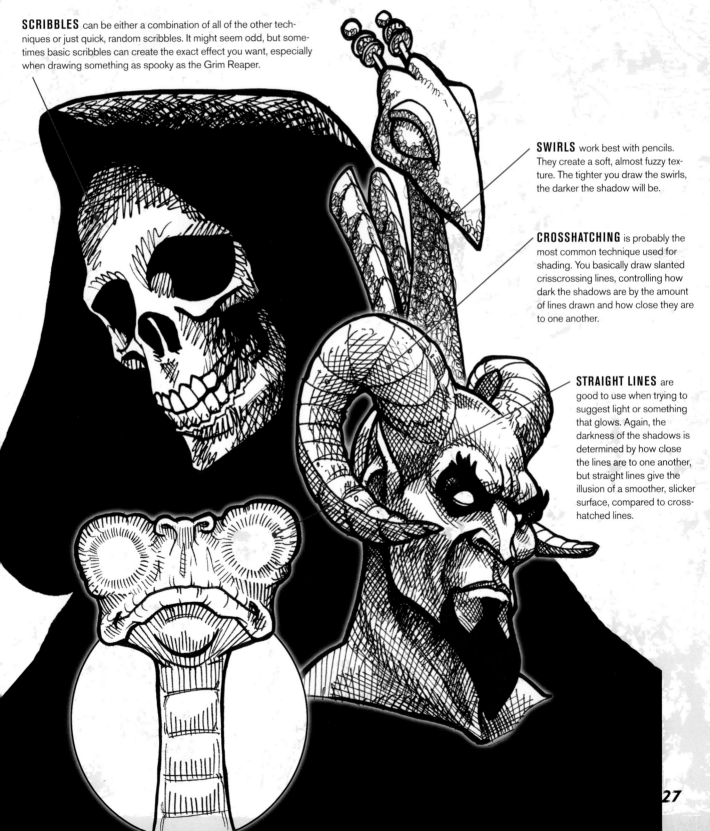

SWIRLS work best with pencils. They create a soft, almost fuzzy texture. The tighter you draw the swirls, the darker the shadow will be.

CROSSHATCHING is probably the most common technique used for shading. You basically draw slanted crisscrossing lines, controlling how dark the shadows are by the amount of lines drawn and how close they are to one another.

STRAIGHT LINES are good to use when trying to suggest light or something that glows. Again, the darkness of the shadows is determined by how close the lines are to one another, but straight lines give the illusion of a smoother, slicker surface, compared to crosshatched lines.

TEXTURE

Monsters and aliens come in all shapes and sizes—and textures. Some are scaly, some are slimy and others have beautiful feathers or colors to fool their prey.

I'll be honest, **FEATHERS** are kind of hard. But you can do it if you take your time. Just like scales, it's a lot of repeating the same shape, but you also have to draw some shafts going down the center of each feather to suggest the texture. For birdlike wings, try to vary the size of the feathers, making them bigger as they near the edges.

The mistake people make when drawing **HAIR** is that they try to draw every strand. The key to drawing hair correctly is creating the larger shapes and then adding limited thin lines to suggest the strands.

SCALES are fairly easy, but time consuming. All you have to do is draw a bunch of U-shapes in rows. (There are some scales that are more like blocks, such as those on an alligator.) You don't even have to draw every scale—just enough to suggest the texture.

FUR is easier to draw than it looks. It's basically short hair, but you want to draw quick scratchy lines to suggest the texture. The more directions the lines go, the scruffier the fur will look, making your monster that much scarier.

Drawing **WATER** or **SLIME** might seem tricky, but think of gravity and remember that drops of liquid always run down. You can also draw a line on the underside of a drop to suggest transparency and gloss.

COLOR

Explaining color is an entire can of worms that I will not go into in this book. But I encourage you to color your art anyway. Use markers, paints, colored pencils or even crayons. You can also scan your art into a computer and color it digitally if you know how to use an image-editing program such as Adobe Photoshop.

The key is to have fun, and remember that it is *your art*. There is no wrong color for anything, especially when it comes to monsters and aliens. My dragon example here shows that any colors will work. Use your imagination!

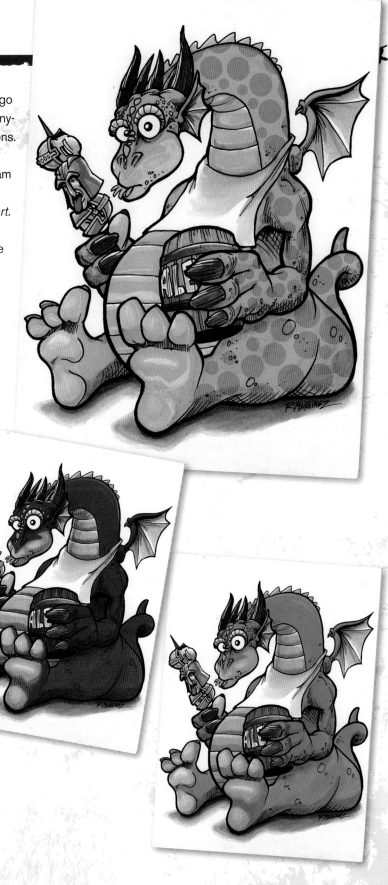

HOW THIS BOOK WORKS

All the creature demonstrations in this book are completed with the same basic steps.

You'll notice that the first few steps in each demonstration show red and blue lines, sometimes over gray lines. The colored lines do *not* mean that you should use colored pencils. The red and blue lines show what you are drawing in that particular step, while the gray lines represent what has already been drawn in previous steps.

The most important thing to remember is that you should always draw lightly until the final step—not so light that you can't see the lines, but light enough that you can erase the lines easily.

1 SKETCH THE POSE

With a *very light graphite pencil*, quickly sketch the position and pose of the creature. You don't need much more than a stick figure at this point, so just start with the basics. (Remember you can use a compass, ruler and other tools to draw basic shapes and lines.)

Draw some guidelines on the head so you'll know where to place the facial features when you add details later. You can also draw small circles to indicate any joints.

2 SKETCH LARGE SHAPES

Use the same pencil to sketch the largest shapes that make up the creature's body. They don't have to be perfect; keep drawing loose for now.

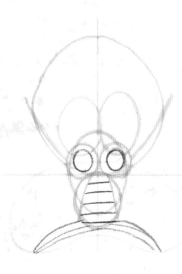

3 ADD SMALLER SHAPES AND ROUGH DETAILS

Using your original guidelines for placement, add the smallest shapes and some of the details. At this point your drawing might look confusing and messy, but that's OK because you'll erase most of the lines after you add the final details.

SKETCH LIGHTLY

I'll say it again: DO NOT SKETCH WITH HEAVY, DARK LINES! Sketch with light, easy-to-read and easy-to-erase lines. When you're ready to add the final lines and details, switch to a darker pencil. Use your darkest pencil (or a black pen or marker) to create any shading and texture at the very end.

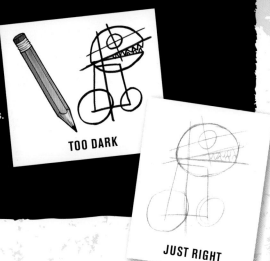

TOO DARK

JUST RIGHT

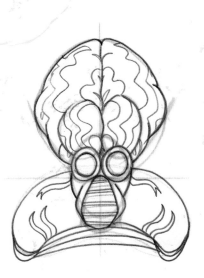

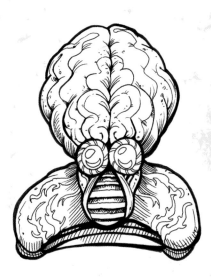

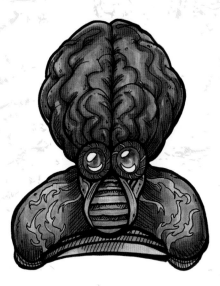

4 DARKEN THE FINAL LINES

Switch to a *darker pencil* and draw over the lines you want to keep. (The lines should still be light enough to erase, but dark enough to stand out from your structure lines.) This is the time to tighten all of the loose shapes you've sketched.

5 ADD FINAL DETAILS

Go over the final lines again with a *black pen or marker*, then erase the pencil lines you no longer need. You can also add details you didn't sketch in previous steps, including shadows and textures.

6 COLOR

When you're satisifed with the drawing, you're ready to add color. Remember—it's *your* drawing, so use your imagination!

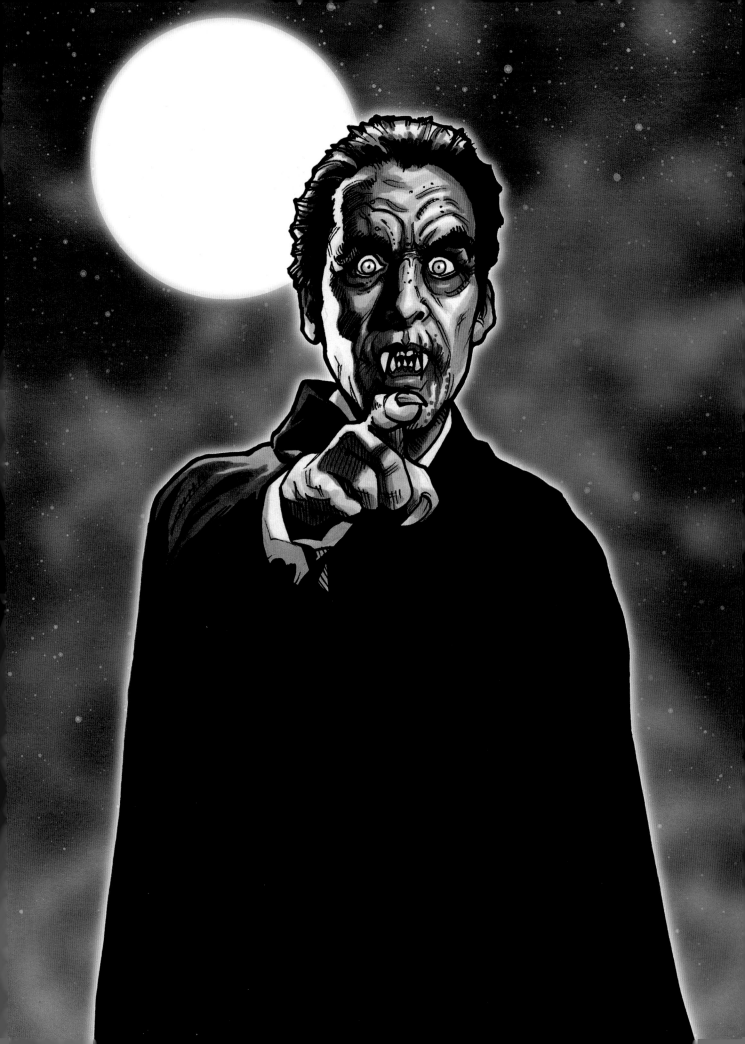

LEGENDARY MONSTERS

Since the dawn of our existence, we humans have been fascinated with things we don't understand—especially the things that frighten us.

Who or what gave that blood-curdling howl heard during the last full moon? What was that shadow seen swimming beneath your boat the last time you were sailing? Why do you feel as if you're being watched when you go camping?

We believe there are creatures out there that we cannot explain, even those that have never been proven to exist. These creatures live in legend. But are they really just stories to keep you tucked in bed at night? Or could they be real?

ALSO KNOWN AS SASQUATCH, Bigfoot is probably the most famous of all legendary monsters. He is said to be an ape-like creature that roams the remote forests of the Pacific Northwest region of the United States and the Canadian province of British Columbia. Standing more than seven feet tall, he is an intimidating presence.

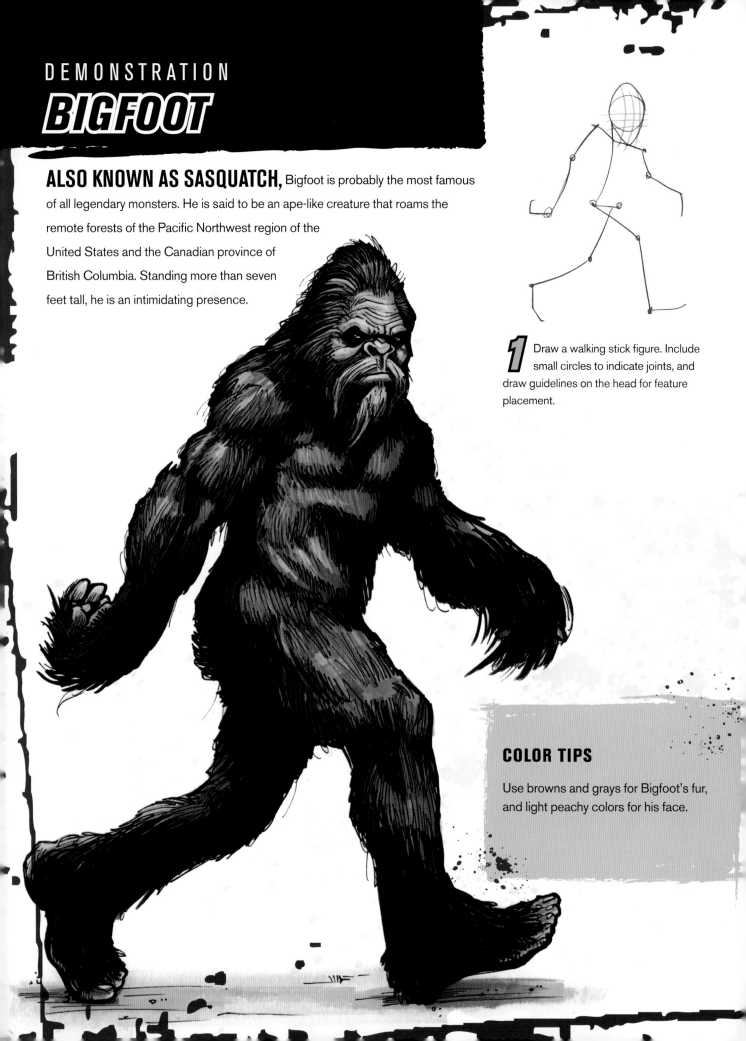

1 Draw a walking stick figure. Include small circles to indicate joints, and draw guidelines on the head for feature placement.

COLOR TIPS

Use browns and grays for Bigfoot's fur, and light peachy colors for his face.

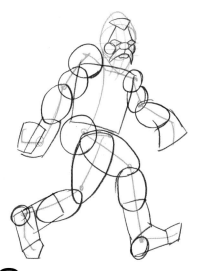

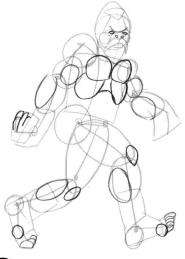

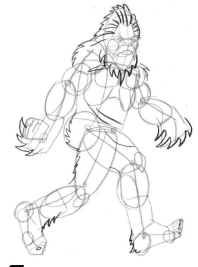

2 Use a lot of circles and chunky shapes to create the bulk and muscles.

3 Add some smaller circles for more definition.

4 Sketch claws and fur shapes.

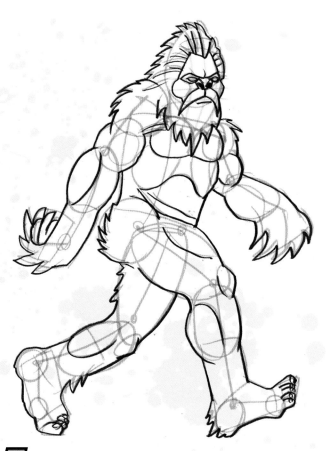

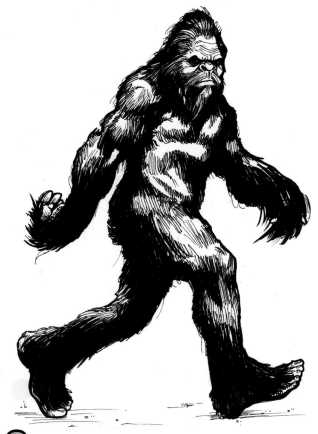

5 Define the creature's form by drawing over the lines you want to keep. Erase the lighter guidelines you no longer need.

6 Add lots of shading and fur texture to make him look shaggy and dirty. Imagine how you would look if you had to live in the woods!

DEMON

DEMONS ARE EVERYWHERE! They lurk in dark corners, sometimes in broad daylight. It is rare for a demon to show itself, however. They like to remain invisible while doing evil deeds. Many people believe that demons are the minions of evil, sent to earth to tempt, abuse and even possess humans.

COLOR TIPS

Use fiery colors like red and orange for the demon's flesh, and ashy colors for its wings.

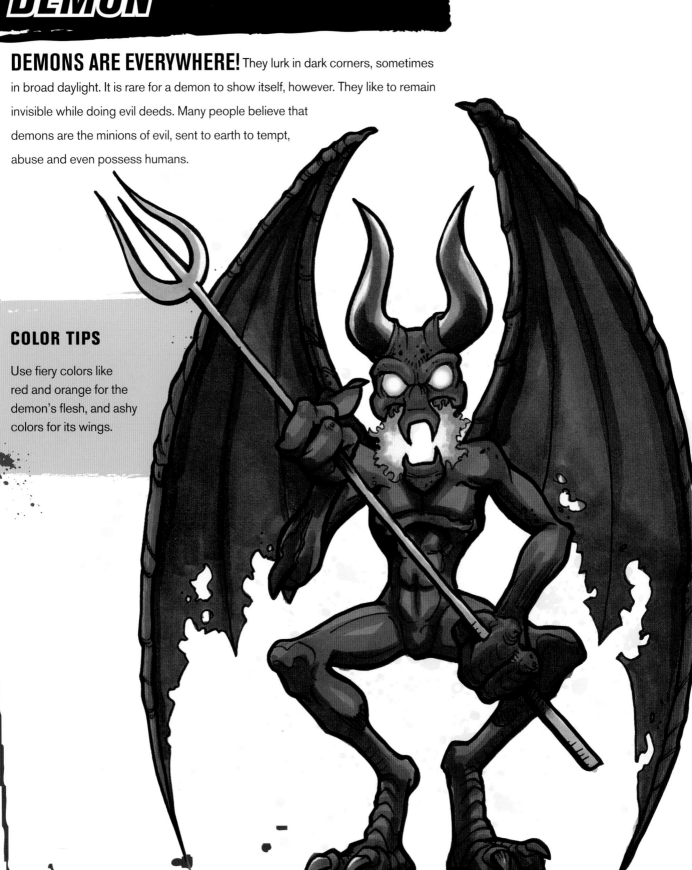

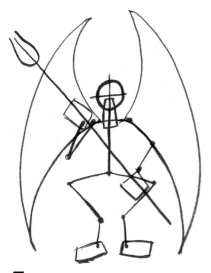

1 Draw a simple stick figure for the position of your demon. Include small circles to indicate joints. Create large curved shapes for the wings, and give the demon a pitchfork to hold.

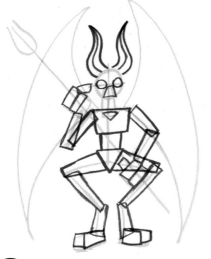

2 Demons are gnarly creatures, so make the shapes of the face and body squarish and pointy. Add some horns on top of the head.

3 Build up the pitchfork and add the smaller features. Draw squiggly lines along the bottom edges of the wings to make them look ragged and old.

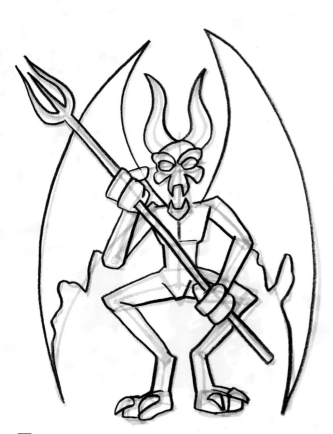

4 Define the shapes by drawing over the lines you want to keep. Erase the lighter guidelines you no longer need.

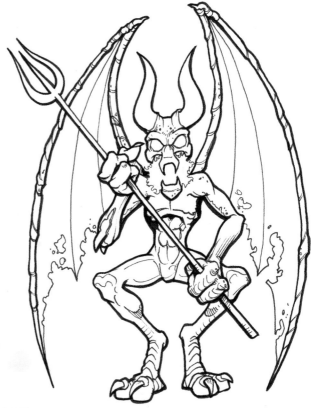

5 Add texture to make the demon look boney and dangerous— think of hard jagged rocks. I like to add bumps and ridges to the skin. Make the wings look tattered to show how old they are.

FRANKENSTEIN'S MONSTER

Victor Frankenstein's most glorious creation **BECAME HIS WORST NIGHTMARE.** In his attempt to create a living man from several pieces and parts of dead human beings, the scientist instead created a monster. Ultimately the monster destroyed all that Frankenstein loved.

COLOR TIPS

Use light, faint colors for the skin to show that he's dead. Pinks at the stitching points will make the wounds look fresh. Color the jacket dark brown or gray.

1 Give the monster a long head and square shoulders. Don't forget the guidelines for his facial features.

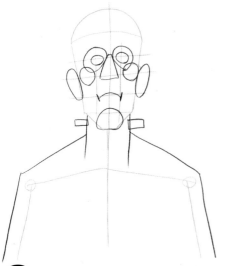

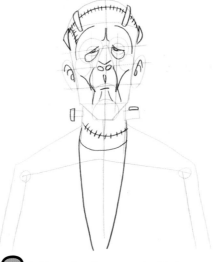

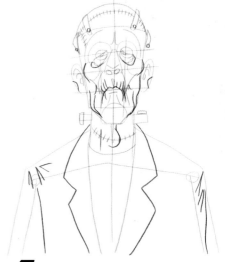

2 Use circles for his saggy facial features, and rectangles for the bolts in his neck. Give him a thick neck and broad shoulders.

3 Add smaller shapes to give his face and neck more definition. He is stitched together from different dead bodies, so be sure to emphasize the stitches.

4 Add some wrinkles to his face and clothes.

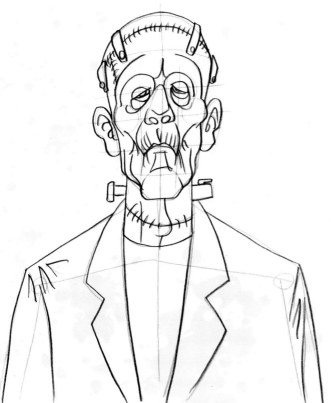

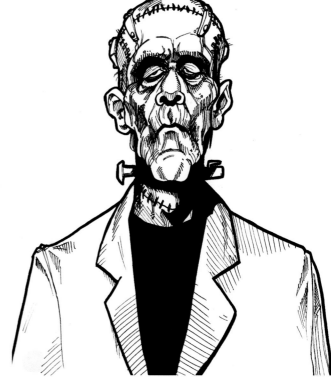

5 Define the monster's form by drawing over the lines you want to keep. Erase the lighter guidelines you no longer need.

6 Pay special attention to the shadows and sagging skin. This creature is one of the "living dead," so his skin isn't going to look well. Use straight lines for the shadows on his jacket.

DEMONSTRATION
GILL-MAN

The Gill-man (as featured in the 1954 film *Creature From the Black Lagoon*) is the last surviving member of a **PREHISTORIC RACE OF HALF-FISH, HALF-HUMANOID CREATURES** that dwelled in the mystic waters of the Amazon. Ferocious when defending his habitat, the Gill-man possesses the strength of ten men. He never leaves his home in the water and only wants to be left alone. An ambitious biologist would be wise to respect the Gill-man's wishes.

COLOR TIPS

Use greens for the skin, and bright blood-red for the eyes. Blue is a general color for water, but experiment with greens and browns to get different kinds of water—muddy, murky or mossy.

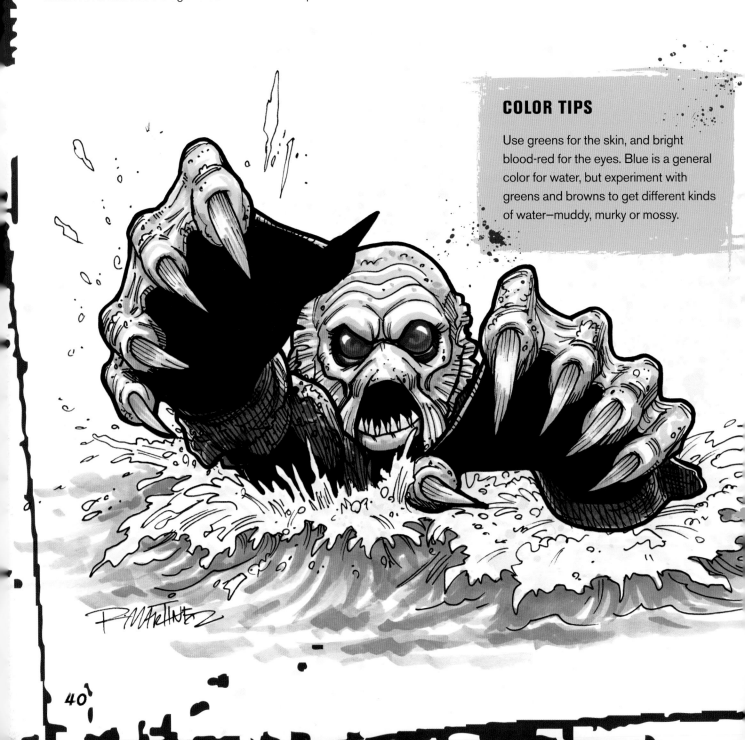

1 Draw an elongated circle for his head, and large squares for his hands. The hand shapes are extra large because they are reaching toward you.

2 Draw ovals for his fingers, and circles for his arm joints. It's OK to overlap shapes because you are building the creature's form.

3 Add pointy shapes for his sharp claws, and refine his facial features.

4 Build up his fingers, gills and teeth. Draw jagged lines to represent the basic shape of the splashing water.

5 Define the creature's form by drawing over the lines you want to keep. Erase the lighter guidelines you no longer need.

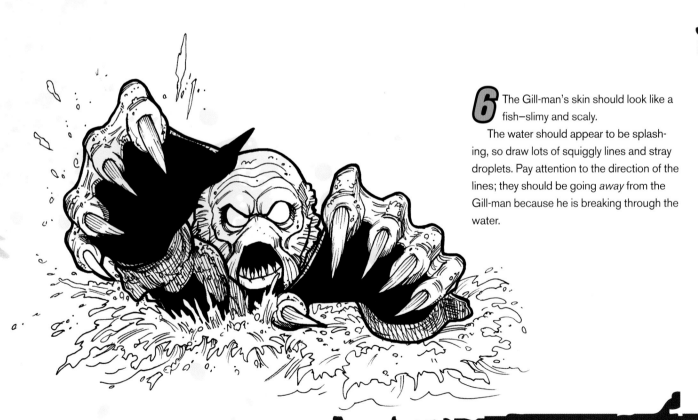

6 The Gill-man's skin should look like a fish—slimy and scaly.

The water should appear to be splashing, so draw lots of squiggly lines and stray droplets. Pay attention to the direction of the lines; they should be going *away* from the Gill-man because he is breaking through the water.

DEMONSTRATION
GREMLIN

Gremlins are **MENACING LITTLE CREATURES WITH AN ATTRACTION TO AIRPLANES,** often causing mysterious malfunctions. They love nothing more than to shred a jet engine or to cause humans to suffer by their own machines. It is not known where gremlins come from, but they are pests not to be taken lightly.

COLOR TIPS

Gremlins come in all kinds of colors. I chose green for this one, but you can use any color combination you like. If your gremlin has hair, make it a bright, wild color so it stands out.

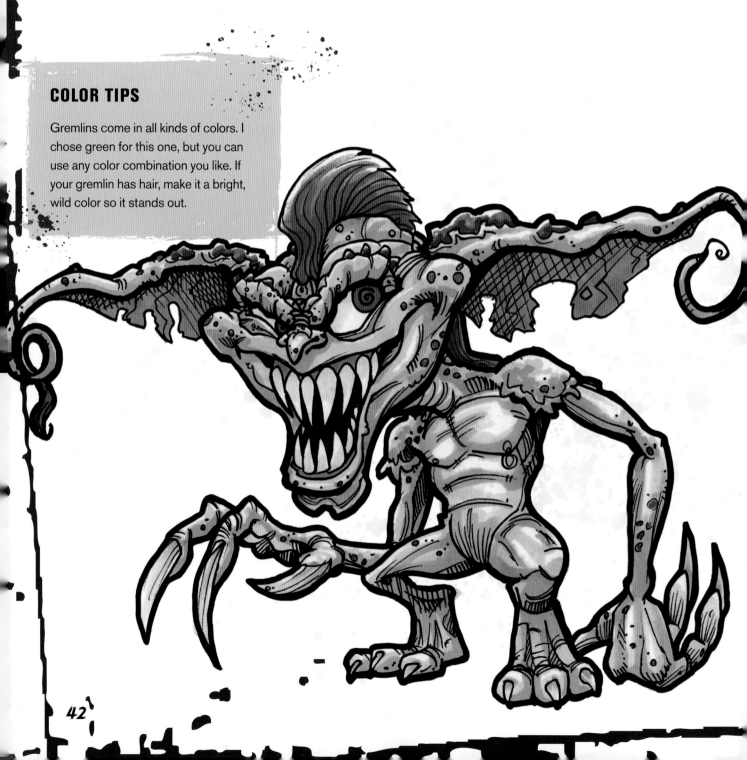

1 Draw a triangle overlapping a circle for the basic shape of the head. Add simple lines for the ears and limbs, but don't forget to include small circles to indicate joints.

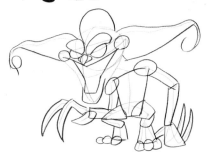

2 Add basic shapes for the facial features, and build up the hair, ears and limbs. Follow your original guidelines so you know where the arms and legs bend.

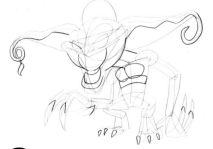

3 Give the features a little more definition. Be creative—I like to put curlicues on the ends of gremlin ears.

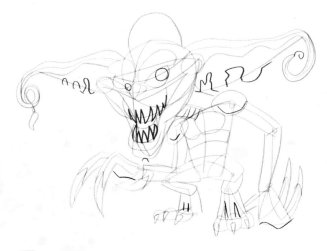

4 Add sharp teeth and beady eyes. Draw some wavy lines on the ears to make them look wrinkly.

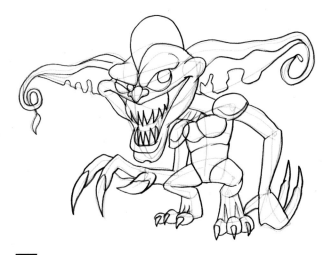

5 Define the gremlin's form by drawing over the lines you want to keep. Erase the lighter guidelines you no longer need.

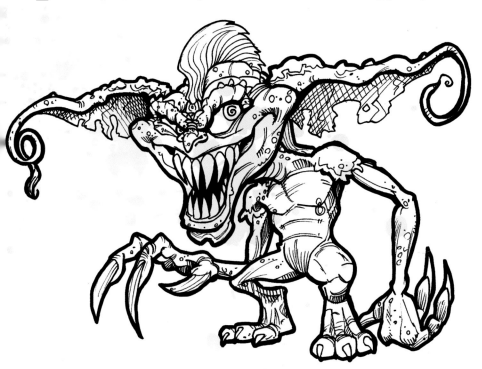

6 Refine the details, including shadows and textures. Use swirls for the pupils to make the eyes look frightening. Add some warts to make the skin look ugly and wrinkled.

GRIM REAPER

THE GRIM REAPER IS OUR GUIDE TO THE LAND OF THE DEAD. He is death personified, often shown as a skeletal figure carrying a large scythe and wearing a black hooded robe. Some cultures believe there is no returning to the living once he has taken you. Others say he can be bribed, tricked or outwitted in order to retain one's life. But the Reaper rarely loses. Your only hope may be to challenge him in his weakest area: board games.

COLOR TIPS

The Grim Reaper is pretty easy when it comes to color. He's bone-white with a black shroud. Use shades of gray for the highlights on the shroud, and lighter gray for the smoke beneath him. The scythe can be black, gray or any color you choose.

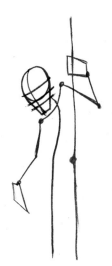

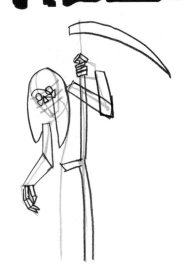

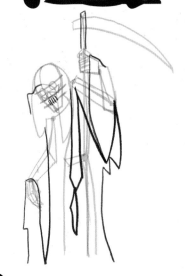

1 Draw guidelines for how you want your Reaper to stand. Start with just a line for the scythe.

2 Give dimension to his head, limbs and scythe. Draw simple circles for his eyes, and some rough lines for his bony fingers.

3 Add some scraggly lines for his tattered robe.

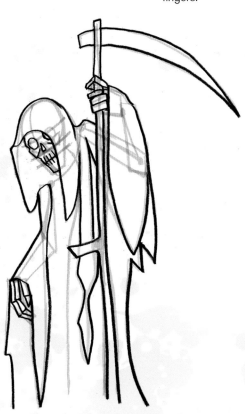

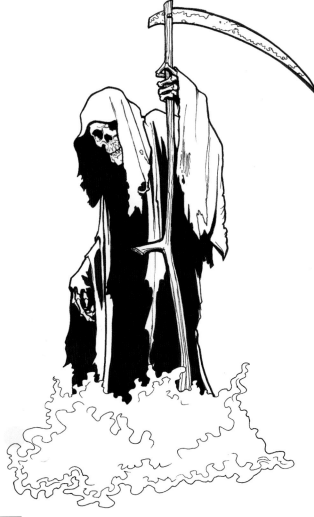

4 Define the Reaper's form by drawing over the lines you want to keep. Erase the lighter guidelines you no longer need.

5 The Reaper is a ghost of sorts. Draw some smoke at his feet to make it appear as if he's floating. Add texture and shadows to his robe, and darken his eyes so they look hollow.

HEADLESS HORSEMAN

During the American Revolution, the British army hired Hessian mercenaries to put down the American rebels. During a battle in 1776, one of the Hessian's horsemen was beheaded by a cannonball. **HE WAS BURIED IN A SMALL TOWN CALLED SLEEPY HOLLOW, WHERE HE IS SAID TO RISE FROM THE GRAVE AND HAUNT TRAVELERS.** Looking for his missing head, he wears a pumpkin in its place.

1 You're drawing a person and a horse, so you need two stick figures. The Horseman's "head" is a pumpkin, and he's holding it, so put a circle at the top of his arm.

COLOR TIPS

It can be difficult to paint highlights on black. The classic comic book trick is to use blue to highlight black. Make the pumpkin deep orange with bright yellows inside for the candle glow.

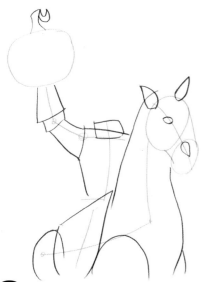

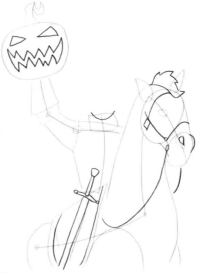

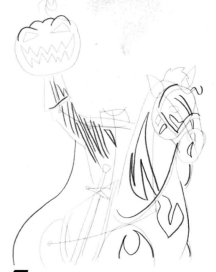

2 Draw the basic shapes that make up both bodies. The horse's body has a lot of curves, while the Horseman starts out kind of boxy.

3 Draw a creepy jack-o'-lantern face on the pumpkin, and add some details to the horse. The sword is made up of small, simple shapes.

4 Sketch in some of the finer details, including the basic shapes of the highlights. The horse and the Horseman's cloak are black, so it's important to draw the highlights before coloring anything. Look at my color image to see where the shapes go.

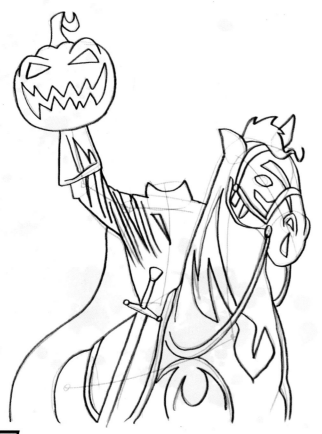

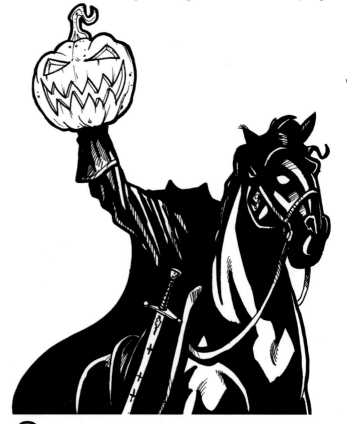

5 Define the shapes by drawing over the lines you want to keep. Erase the lighter guidelines you no longer need.

6 Being careful not to color over the shapes you drew in step 4, fill in the black areas of the Horseman and his horse. Give some texture to the pumpkin.

LOCH NESS MONSTER

THE LOCH NESS MONSTER IS ONE OF THE GREATEST MYSTERIES

in the *cryptozoology* field book. (Cryptozoology is the study of and search for animals that fall outside of contemporary zoological categories.) It is believed that the Loch Ness Monster, commonly referred to as "Nessie," is a species of dinosaur called plesiosaur, which is a long-necked water-dwelling dinosaur that has flippers instead of legs. They reach lengths of 45–50 feet (14–15m) and are terrific swimmers. Somehow, these dinosaurs survived extinction and live in the frigid depths of Loch Ness in Northern Scotland. Sightings of Nessie have been reported for hundreds of years, but with the exception of a few blurry photos and questionable videos, the Loch Ness Monster has managed to remain veiled in legend.

COLOR TIPS

Nessie is greenish-gray but light in tone. The waters of Loch Ness are dark brown from the peat of the Scottish highlands, so make the water brown and murky.

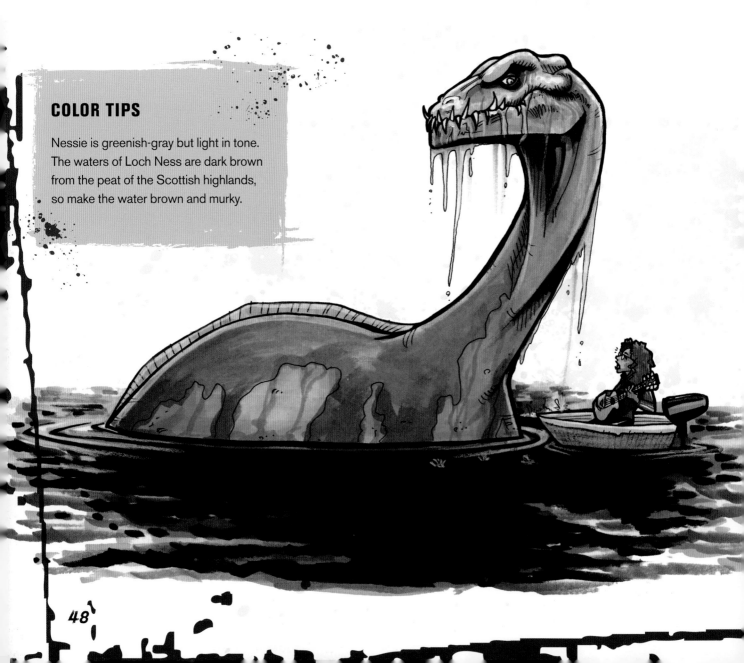

1 Start with two ovals connected by a curved line.

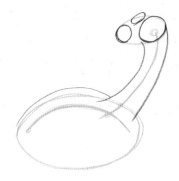

2 Build up the neck, and sketch the basic shapes of Nessie's facial features.

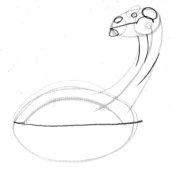

3 Draw a line through the body to represent water; extend the line across the entire page. Add some smaller shapes to the face, and give some dimension to the neck so it appears to be turning.

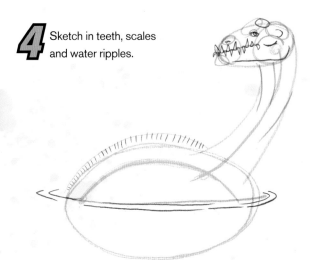

4 Sketch in teeth, scales and water ripples.

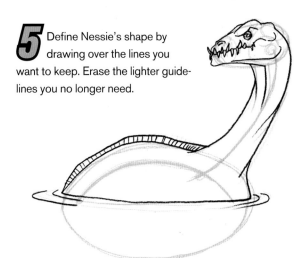

5 Define Nessie's shape by drawing over the lines you want to keep. Erase the lighter guidelines you no longer need.

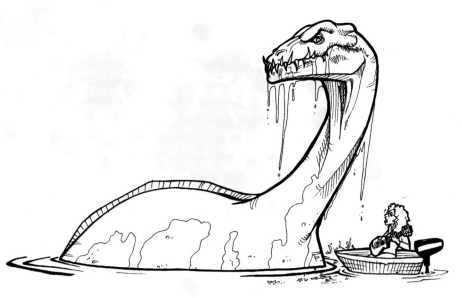

6 Water drops can be tricky. Notice that the ones I drew point downward and are thicker at the top than at the bottom. You might want to study real water to help you draw it correctly. Go to a sink and cup some water in your hand. Notice as the water leaks through your fingers, it gathers beneath your hand before it drips. That's the effect you want. It makes it look like Nessie *just* popped out of the water.

You may want to add a bird or even someone in a rowboat to show Nessie's size.

MEGALODON (GIANT SHARK)

The megalodon (meaning "big tooth") was **A GIANT SHARK THAT LIVED IN PREHISTORIC TIMES,** between about 18 million to 1.5 million years ago. An adult megalodon could grow to a length of 56 feet (17m) and weigh more than 40 tons (40,000kg). It is widely believed that megalodons are extinct, but some say they still exist in the deep unknown of the oceans.

COLOR TIPS

Similar to the great white shark, megalodons have gray backs and pure white undersides. Use pink for the gums.

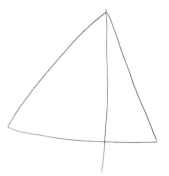

1 Start with a large triangle to represent the basic shape of the body. Add a guideline to help place the rest of the shapes.

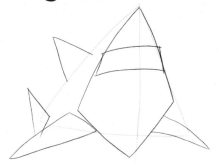

2 Draw a diamond for the face, and triangles for the tail and fins.

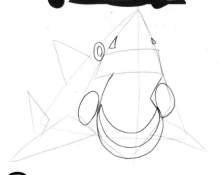

3 Sketch the eyes, nostrils and open jaw.

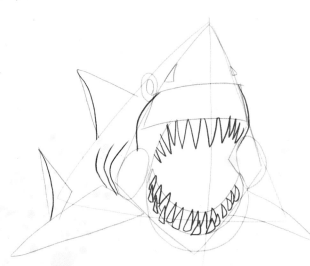

4 Add the sharp teeth. Define the back fin, tail and gills with curved lines.

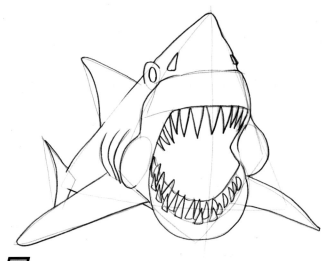

5 Define the shark's form by drawing over the lines you want to keep. Erase the lighter guidelines you no longer need.

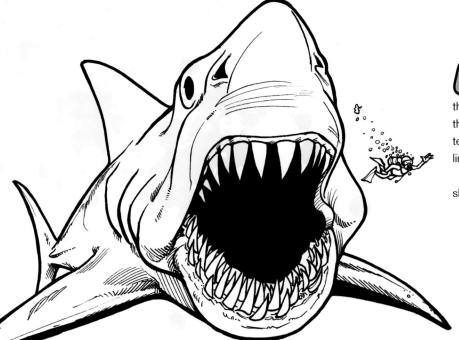

6 Shadows in water generally come from an overhead light source, so the shadows in this drawing should be on the underside of the shark. For the smooth texture of the shark's skin, use clean, smooth lines.

You may want to add a scuba diver to show the large size of the shark.

DEMONSTRATION
MUMMY

Tombs of the Egyptian pharaohs were **FILLED WITH GOLD AND TREASURES FOR THEIR JOURNEY TO THE LAND OF THE DEAD,** and their bodies were preserved by a process called mummification. These mummies lay quietly in their tombs until unsuspecting explorers or grave robbers disturb their peace.

1 Here you are dealing with something called foreshortening. The mummy's right hand is coming toward you, so his left arm should be partially covered by his right hand.

COLOR TIPS

Use light browns and grays for the stone coffin, and light grays for the mummy's wrappings. Put some bright yellow in the eyes if you want the mummy to look like it's coming back to life.

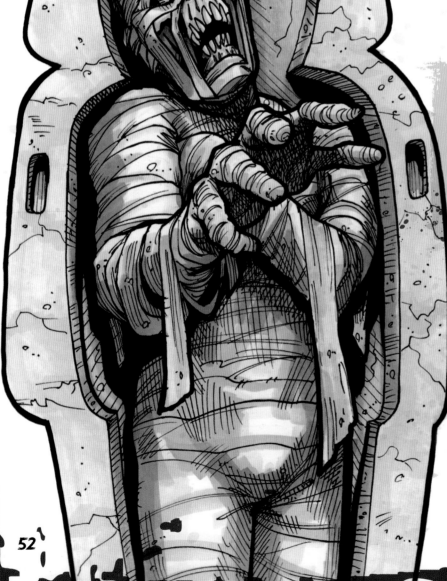

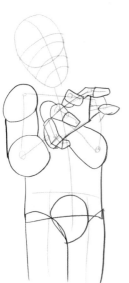

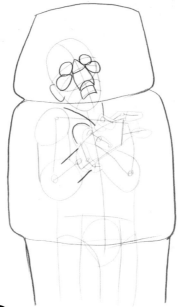

2 Start building the body and hand. Keep things loose for now, and don't be intimidated by all the overlapping shapes.

3 Sketch the facial features. Draw the basic shapes of the coffin around the mummy's body.

4 Now you need to do some foreshortening with the tomb. A simple trick is to mimic the line you already drew, but make it smaller inside and a smidge lower. Refine the mummy's face and add the teeth.

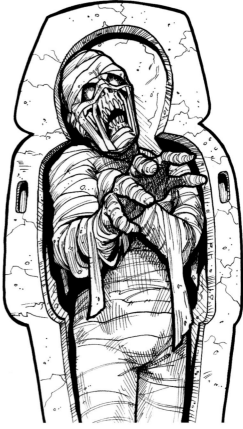

5 Define the shapes by drawing over the lines you want to keep. Erase the lighter guidelines you no longer need.

6 Use thin lines for the texture of the wrappings to give the illusion of lightweight material. Add cracks and pebbles to the coffin so it looks old and worn.

SWAMP MONSTER

Swamp monsters live deep in the bayous and everglades of the American South.

Descriptions of swamp monsters are hard to come by because few who see one live to tell about it. **IT IS SAID THAT THE SWAMP SIMPLY COMES TO LIFE AND CAN SWALLOW A MAN WHOLE.** While few eyewitnesses exist, the swamp monster's terrible scream can be heard for miles.

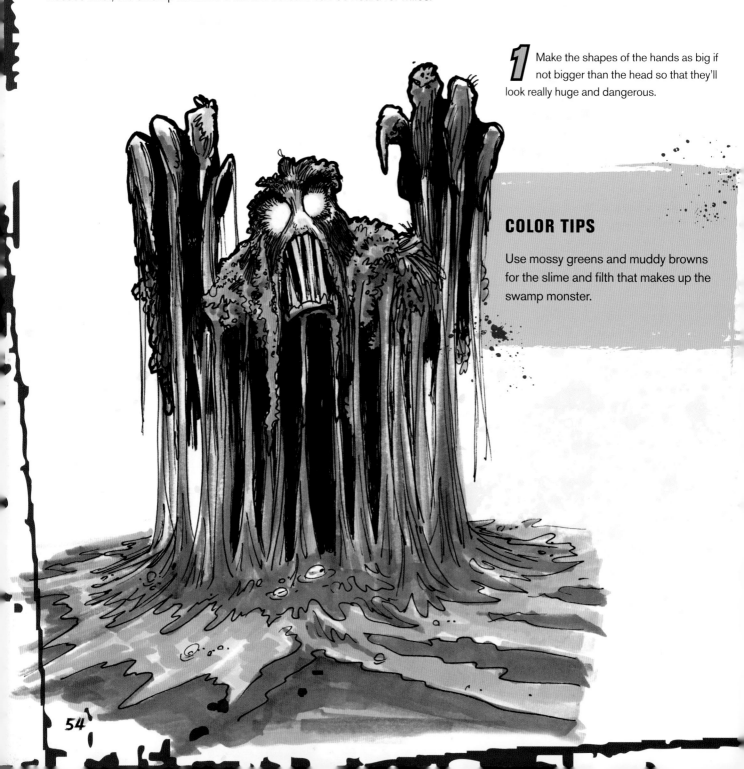

1 Make the shapes of the hands as big if not bigger than the head so that they'll look really huge and dangerous.

COLOR TIPS

Use mossy greens and muddy browns for the slime and filth that makes up the swamp monster.

54

2 Fill out the body and arms. Draw oval shapes for the fingers.

3 Sketch the facial features and claws. Draw vertical lines for the dripping slime, and two horizontal lines to represent the swamp.

4 Add more slime, and draw some shaping lines for the swamp and the monster's head.

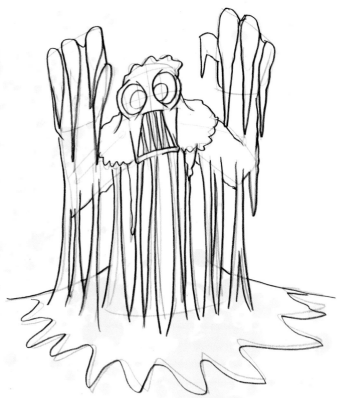

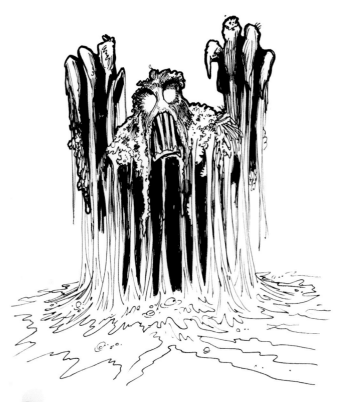

5 Define the monster's form by drawing over the lines you want to keep. Erase the lighter guidelines you no longer need.

6 The swamp monster is made of moss, sticks and slime. Use any and all kinds of techniques from pages 27 and 28 to create the textures.

DEMONSTRATION
VAMPIRE

Probably **THE MOST FAMOUS AND FEARED MONSTERS,** vampires are cursed humans who have transformed into immortal beings who must drink blood to stay alive. Vampires look like humans, except for the long fangs that puncture the skin of their victims. Often those bitten will become vampires themselves. Holy water, crucifixes, garlic and silver are known to ward off vampires. But to destroy one, you must either drive a wooden stake through its heart or trick it into being exposed to sunlight.

1 You need two stick figures for this drawing. Start with the vampire, then use the position of his hand as a guide to place his victim.

COLOR TIPS

Vampires are "undead," so their skin is pale in color. The victim, however, should be full of color in the face, as she has not yet been bitten and had her blood sucked. Use dark grays and blacks for the vampire's cape, and put some green or yellow in his eyes to make them glow.

 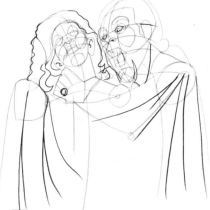

2 Sketch the facial features of both figures, and the basic outline of the victim's hair.

3 Start to refine some of the features, including the vampire's hand and fangs. Add lines to represent the basic shape of his cape.

4 When drawing shapes for the victim's curly hair, keep your hand loose. DO NOT draw every strand of hair; draw clumps of hair.

Add some swooping lines from the vampire's hand and shoulders to give the illusion of fabric where the cape hangs.

 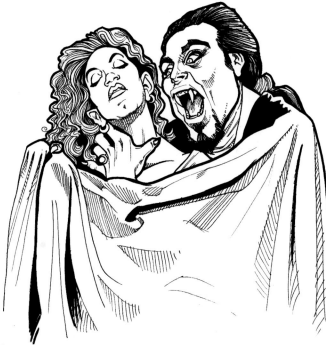

5 Define the shapes of the figures by drawing over the lines you want to keep. Erase the lighter guidelines you no longer need.

6 Hair is tricky. As I said, you don't have to draw every hair. Simply draw the wave or direction of the hair in small sections.

Shadows can be difficult if you are not used to drawing fabric. Study your own clothes to see how the light shines on fabric, and you will notice little shadows where the folds and ripples are. It takes practice, but you can do it!

DEMONSTRATION
WEREWOLF

The legend of the werewolf has been told for thousands of years. Several cultures have stories of **SHAPESHIFTING HUMANS WHO TURN INTO FEROCIOUS WOLVES** and crave the flesh of humans. Modern werewolf legends state that a full moon will trigger the change in a lycanthrope (werewolf), until the bloodline of the werewolf is severed. A single bite or scratch from a werewolf can infect its victim with the curse—if the victim is lucky enough to survive. According to legend, the only way to kill a werewolf is by shooting it with a pure silver bullet.

1 The werewolf has huge claws, so draw large shapes for the hands and feet. Sketch lots of circles for the bulky, muscular body and limbs. Because the werewolf is hunched forward, its head should be at about the same level as its shoulders.

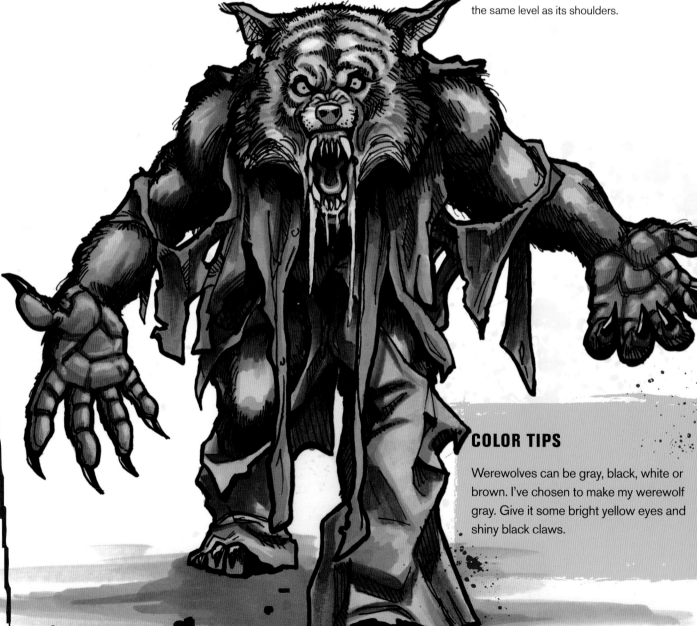

COLOR TIPS

Werewolves can be gray, black, white or brown. I've chosen to make my werewolf gray. Give it some bright yellow eyes and shiny black claws.

2 Draw the basic shapes of the facial features as well as the fingers and toes. For the ripped shirt, draw some U-shapes hanging from the body.

3 Sharpen the finger claws and add some fangs. Add more features to the face, and draw some chunky shapes on the legs for the ripped pants.

4 Add claws to the toes, and use curved lines to make the brow look angry and savage. Draw some lines to represent drool hanging from the fangs.

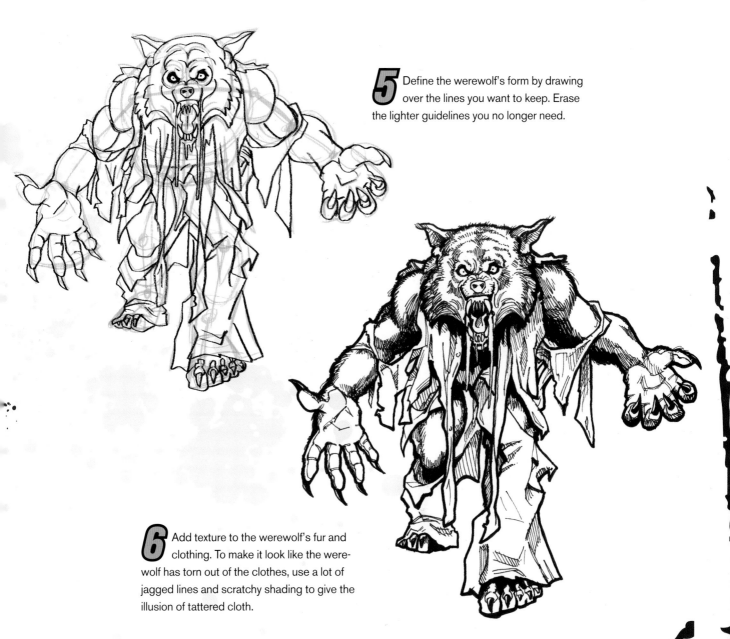

5 Define the werewolf's form by drawing over the lines you want to keep. Erase the lighter guidelines you no longer need.

6 Add texture to the werewolf's fur and clothing. To make it look like the werewolf has torn out of the clothes, use a lot of jagged lines and scratchy shading to give the illusion of tattered cloth.

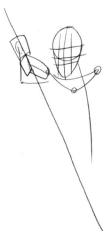

Witches have long been associated with evil spirits and spells. A witch or warlock (male witch) is **A PERSON WHO PRACTICES THE ART OF WITCHCRAFT,** a practice that was seen as ungodly or even satanic in early times. Witches exist in many forms, but the portrayal of the evil witch who eats children generally only appears at Halloween.

1 Start with basic guidelines, giving close attention to the hands gripping the broomstick. Instead of drawing one big shape, draw a shape for the hand and another shape for the bunched-up fingers.

COLOR TIPS

Witches wear a variety of things they find, or that they take from their victims. Mix dark colors with bright colors, like in the red scarf I've made here.

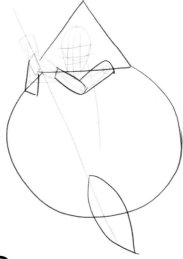

2 Draw a triangle and a large circle for the basic shape of the witch's cape. Add rectangular shapes for her arms. The basic shape of the broom bristles is that of an almond.

3 Sketch the facial features and the basic lines for the hair and scarf. Her fingers are oval-shaped, and only four can be seen on each hand because her thumbs are gripping the broom handle from the opposite side.

4 Refine the witch's hair and facial features. Build up the broom handle, and draw some squiggly lines to represent torn edges on the cape.

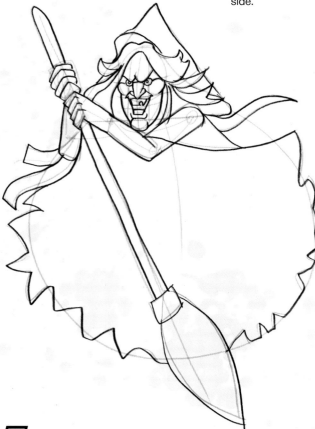

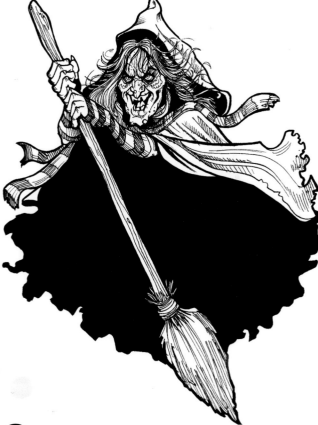

5 Define the shapes by drawing over the lines you want to keep. Erase the lighter guidelines you no longer need.

6 Because the witch is flying high in the night sky with the moon above her, the shadows are beneath her. It's so dark you can't even see her body or feet!

Give the broom handle and bristles texture, and add some warts to the witch's face. I also added a thumb with a pointy nail to her top hand.

DEMONSTRATION
YETI

The Yeti, also known as "The Abominable Snowman," is said to live in the Himalayan Mountains in Nepal and Tibet. The Yeti stands from 6 to 9 feet (2–3m) tall and is covered with long, coarse hair to protect it from the elements. **MUCH ABOUT THE YETI REMAINS A MYSTERY** as few have seen this mysterious creature, but hair samples and giant tracks left in the snow keep the Yeti's legend alive. Some people believe the creature is a relative of Bigfoot.

1 The Yeti is huge and lurching. Make the back hunched and the head bent forward as if the creature is climbing up a mountain.

COLOR TIPS

Even though the Yeti is basically white, you can still add color to indicate shadows and highlights. Make the eyes yellow to suggest a haunting glow.

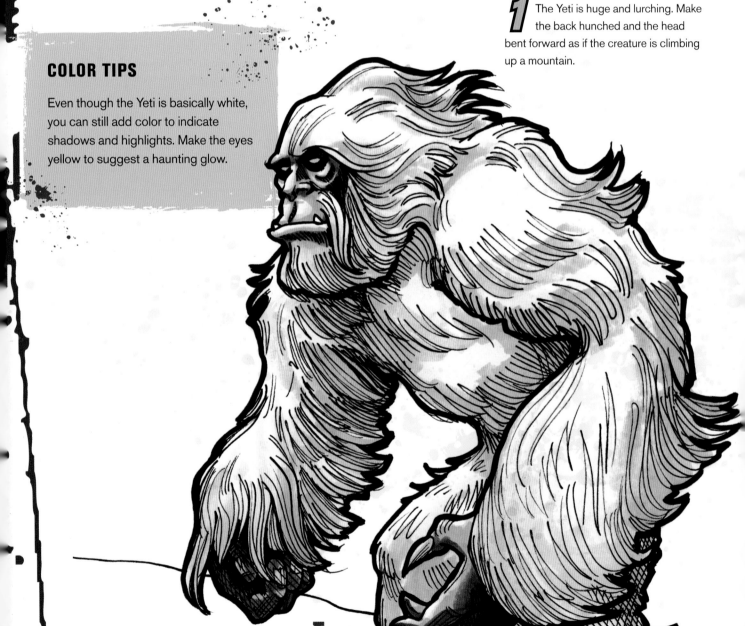

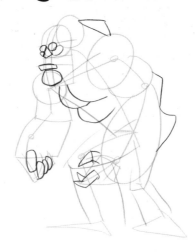

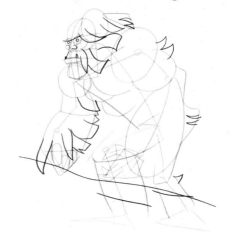

2 Extend the head, and draw large chunky shapes for the arms and legs.

3 Add the facial features and fingers. Use your guidelines to place the eyes in the proper place. Draw pointed shapes on the back to represent hair that is sticking out.

4 Refine the facial features, and add some more chunks of hair. Draw a diagonal line to represent a snowy mountain. The snow will cover the feet, so you don't have to worry about those.

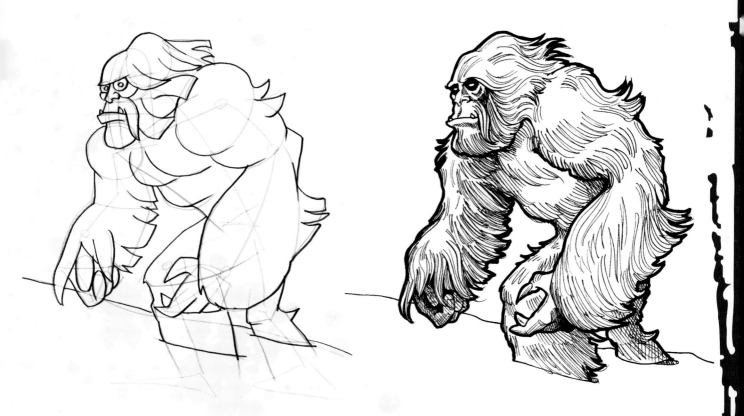

5 Define the Yeti's form by drawing over the lines you want to keep. Erase the lighter guidelines you no longer need.

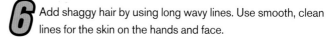

6 Add shaggy hair by using long wavy lines. Use smooth, clean lines for the skin on the hands and face.

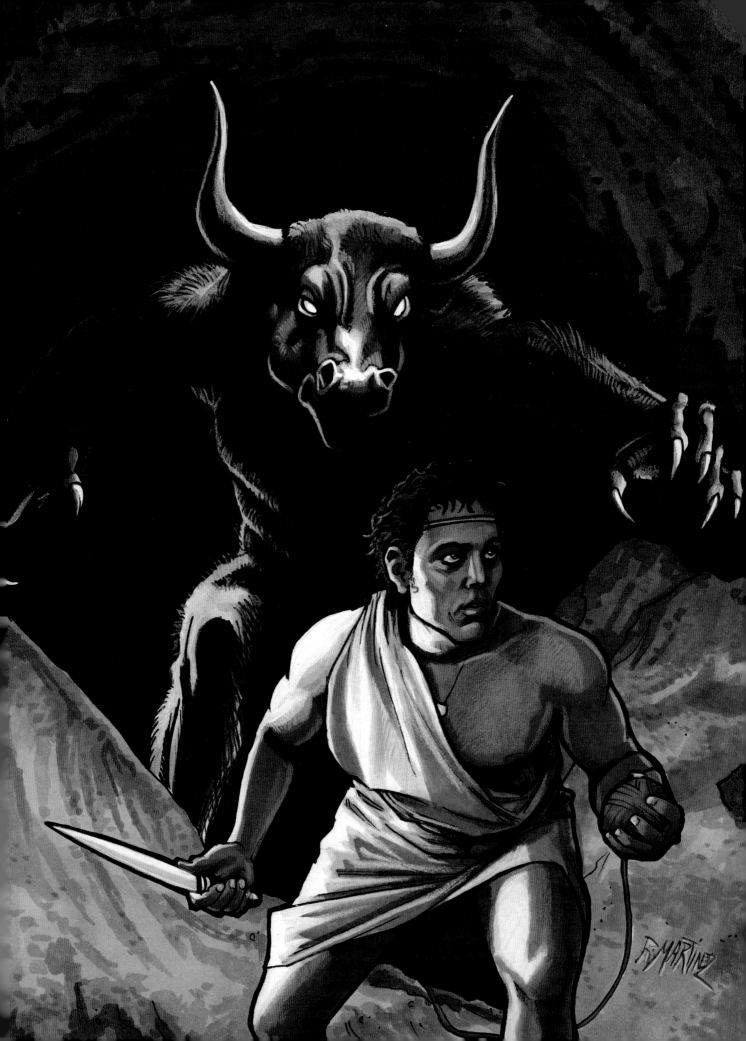

MYTHOLOGICAL CREATURES

In the early days of civilization, the world's cultures told stories of mighty gods, fantastic heroes and savage beasts. These tales were filled with magic and events that shaped the world as they knew it. Many believed the creatures represented our deepest fears and inner demons and the heroes our ability to defeat them. Were these creatures created from wild imaginations? Or did they really once walk, crawl and roam the earth?

DEMONSTRATION
CERBERUS

Known as the hound of Hades in Greek mythology, **THE CERBERUS WAS A MONSTROUS THREE-HEADED DOG RESPONSIBLE FOR KEEPING THE DEAD IN AND THE LIVING OUT.** Although a formidable foe for any common man, the hellhound was overcome several times with the aid of gods or superhuman talents. Siblings of the Cerberus include the Chimera (page 68) and the Hydra (page 76).

1 This mean puppy has three heads, but only one body. Draw your stick figure carefully, making sure to leave plenty of space between the heads for ears, hair and details.

COLOR TIPS

Use light browns and grays for the fur, but make the raised chest a little lighter in color. Don't forget the glowing yellow eyes.

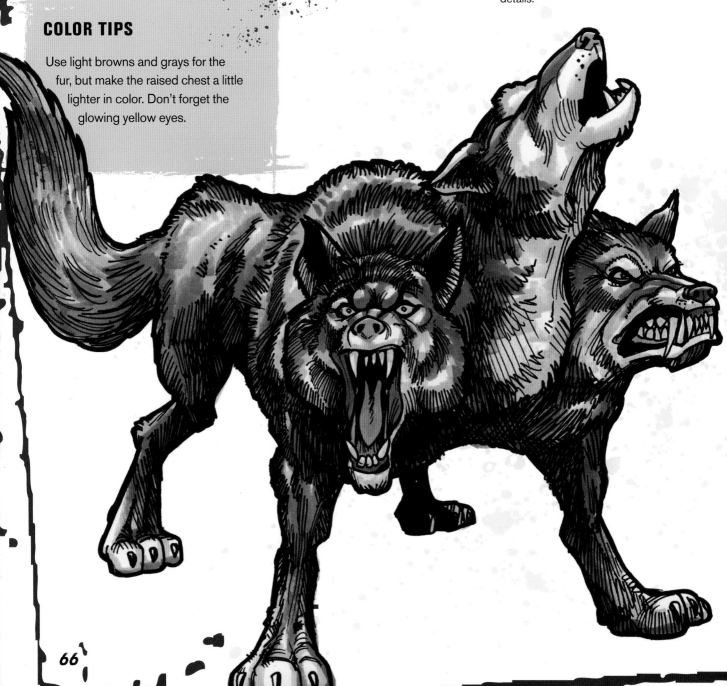

2 Use a variety of shapes to build up the body and heads.

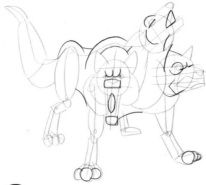

3 Use the guidelines you drew in step 1 for proper placement of the different facial features.

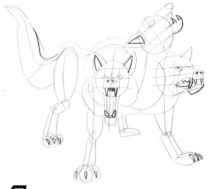

4 Tighten your shapes, and add some sharp teeth and claws.

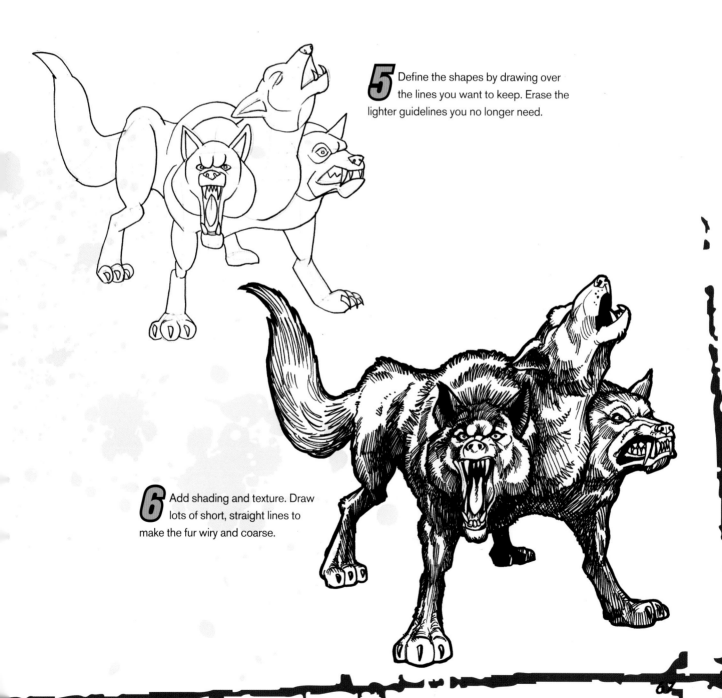

5 Define the shapes by drawing over the lines you want to keep. Erase the lighter guidelines you no longer need.

6 Add shading and texture. Draw lots of short, straight lines to make the fur wiry and coarse.

CHIMERA

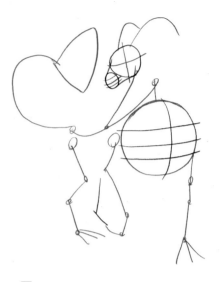

One of several creatures from Greek mythology with multiple heads, **THE CHIMERA WAS AMONG THE MOST FEARED BECAUSE IT POSSESSED THE STRENGTHS OF THREE DIFFERENT BEASTS,** as well as the ability to breathe fire. The Chimera stalked the area of Lycia in Asia Minor, terrorizing its citizens until the hero Bellerophon eventually defeated it. With the help of the winged horse Pegasus, Bellerophon was able to shoot the Chimera from the sky, where he was safe from the beast's heads and fiery breath.

1 This is a three-headed monster, so leave room in your stick figure for all three heads and their features. I suggest you start with the lion body and head, then draw the goat head, and finish with the snake.

COLOR TIPS

Use gold colors for the lion, light gray for the goat, and greens for the snake. The lion's mane should be darker than its body.

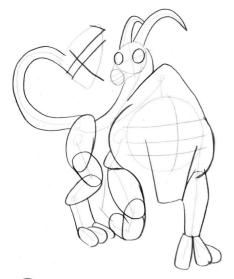

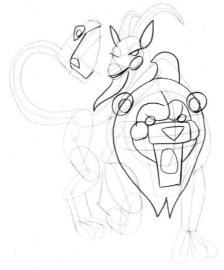

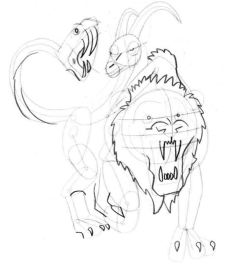

2 Use a variety of shapes to build the different creatures. Use S-curves for the snake and the goat's horns.

3 Add tighter shapes for the facial features, and the lion's mane and the goat's beard.

4 Give the snake and lion some sharp fangs, and define the lion's mane and claws.

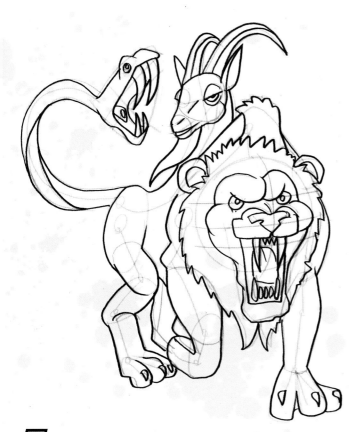

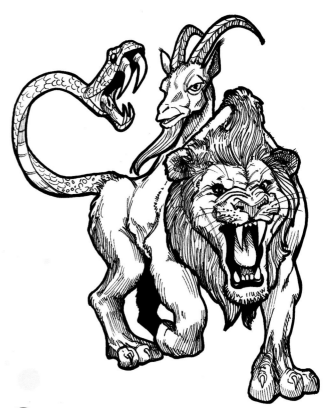

5 Define the shapes by drawing over the lines you want to keep. Erase the lighter guidelines you no longer need.

6 The Chimera has many different textures, so make sure you include everything from scales to fur and hair. The texture of the goat's horns is similar to that of the snake's scales.

CYCLOPS

The Cyclops is one of the most feared creatures that may be met on a hero's journey.

CYCLOPES ARE A RACE OF GIANTS, EACH WITH A HUGE SINGLE EYE BELOW ITS BROW.

They despise puny humans and love to keep them as pets or eat them alive. Although the one-eyed giants possess great strength, they suffer from an uncommonly slow wit.

COLOR TIPS

The Cyclops is basically an overgrown human. In this case, I used a lot of peach and pink colors for his flesh. His clothes should be simple and drab.

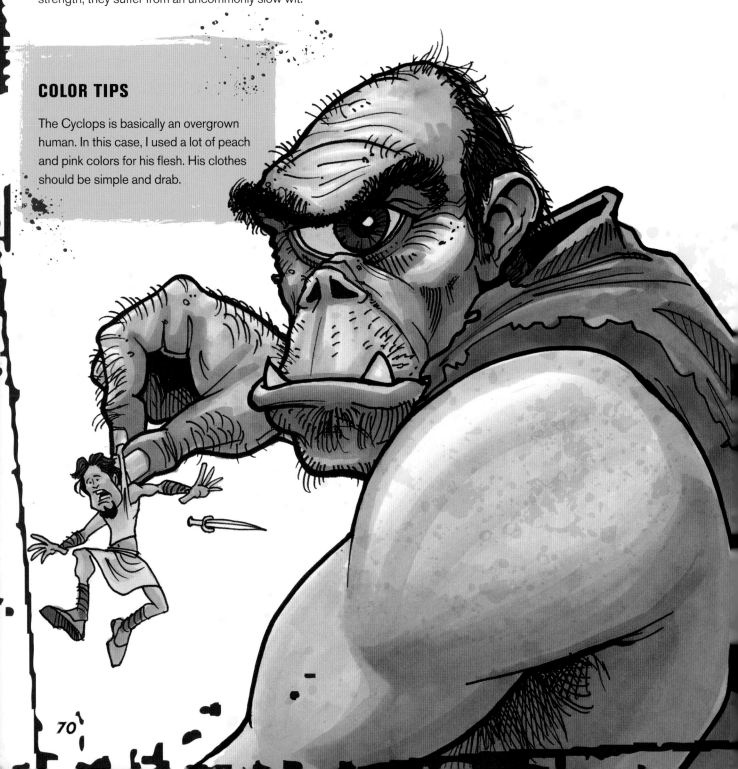

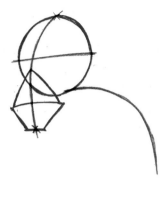

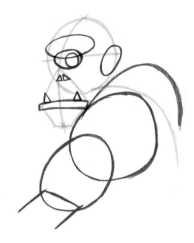

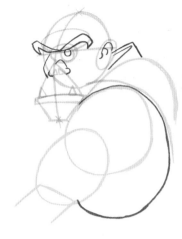

1 Start with a simple head, large jaw and hunched backbone.

2 Use circles and ovals for his body and eye, and triangles for his sharp teeth and flared nostrils.

3 Add a curved brow close to the eye, and refine the rest of the features.

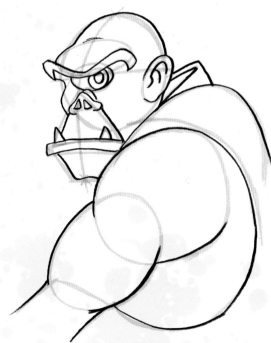

4 Define his form by drawing over the lines you want to keep. Erase the lighter guidelines you no longer need.

5 Add more features, such as hair and wrinkles. You can even draw a hand holding the Cyclops' next victim to show his gigantic size.

DRAGON

Of all the mythological monsters, none is more iconic and intriguing as the dragon. **KNOWN FOR ITS FIERCE APPEARANCE AND MAGICAL POWERS, THE DRAGON IS REVERED BY MAN AND BEAST ALIKE.** Many ancient cultures have referenced the mighty dragon in their art, architecture and legends. Most interesting is that despite these cultures never knowing of one another's existence, all of them typically had the same description of the dragon: a serpent-like creature with scales, large teeth, horns, large wings and often the ability to breathe fire or a variety of other elements such as acid or ice.

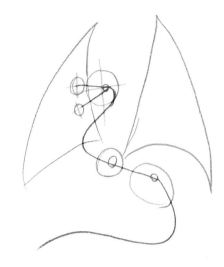

1 Start with a big S-curve for the basic shape and position of the dragon. Sketch circles and ovals for the body and head, and triangles for the wings. Don't forget to include guidelines on the head; you'll need them later for feature placement.

COLOR TIPS

Dragons come in all colors. Their skin is usually bright, while their horns and claws are light like bone or dull like ash. Make the rock perch dark so the bright dragon will stand out.

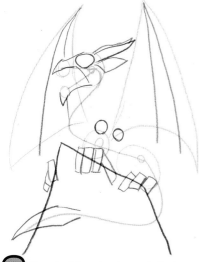

2 Start building the dragon's features, and add the basic shape of the rock perch.

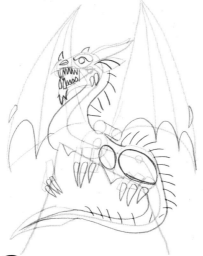

3 Use a variety of shapes and lines to define the body, wings, spikes and fangs.

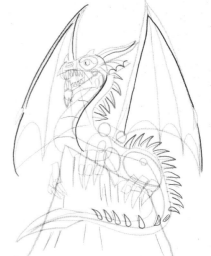

4 Tighten some of the finer details, such as the wings and spikes along the back and tail.

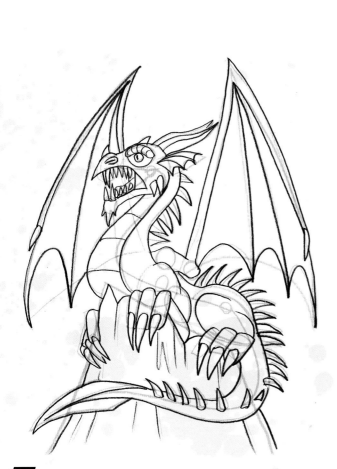

5 Define the shapes by drawing over the lines you want to keep. Erase the lighter guidelines you no longer need.

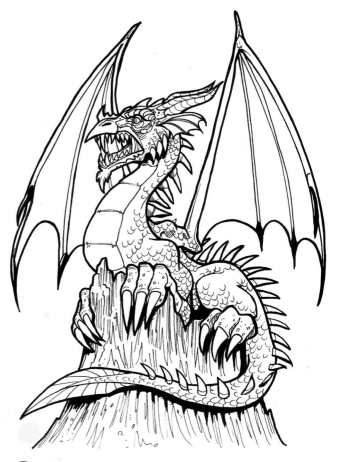

6 Dragons have big, tough scales, so be sure to draw lots of them along the back and tail. Add jagged lines to the rock perch to make it look hard and rough.

DEMONSTRATION
GRIFFIN

A great beast of many powers, the griffin is said to have the head, talons and wings of an eagle, and the body and hind legs of a lion. As both "king of the jungle" and "ruler of the sky," **THE GRIFFIN IS CONSIDERED ONE OF THE MOST NOBLE AND RESPECTED OF ALL MYTHOLOGICAL CREATURES.** The Greeks, ancient Minoans, Egyptians and Asian cultures all had their own version of the majestic griffin, yet all shared similar descriptions.

Griffins symbolize divine power and are generally known for guarding treasure. They have survived the test of time and are still seen throughout the world in art, architecture, royal crests and logos.

COLOR TIPS

Griffins are gold and brown in color. I chose to give this one white head feathers like a bald eagle. Make its beak yellow like its eyes, and give it some shiny black claws.

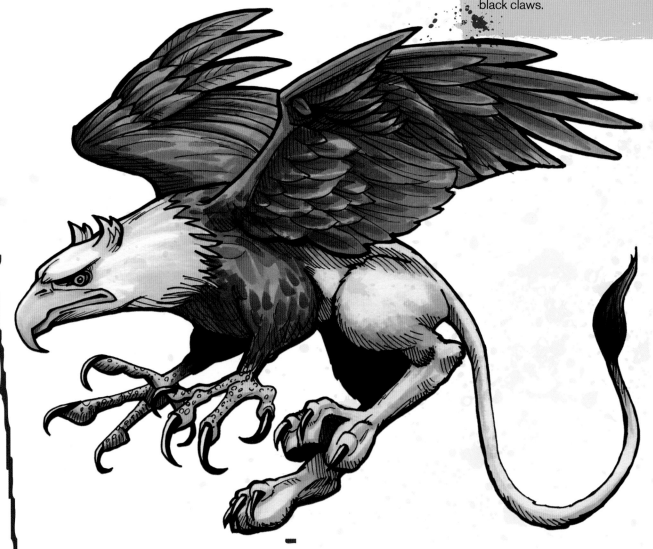

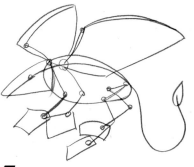

1 Use rounded shapes for the lion half, and triangular shapes for the eagle half. Draw an S-curve with an almond shape at the end for the lion tail.

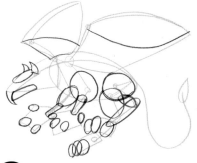

2 Add tighter shapes to build the lion body and the eagle head.

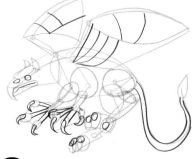

3 Give a little more form to the head, wings and tail. Use sharp curves for the eagle talons.

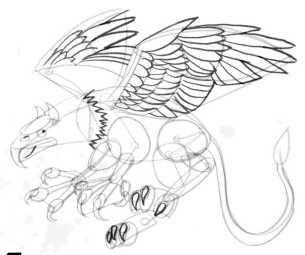

4 Take your time drawing the feathers. The layered pattern is necessary to make them look like wings.

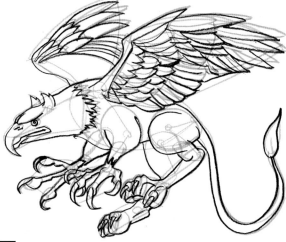

5 Define the creature's form by drawing over the lines you want to keep. Erase the lighter guidelines you no longer need.

6 Add a variety of textures: the lion body has short fur with a tuft of hair at the end of the tail; the eagle has both regular feathers and feathers that look like fur, and talons that are a little scaly.

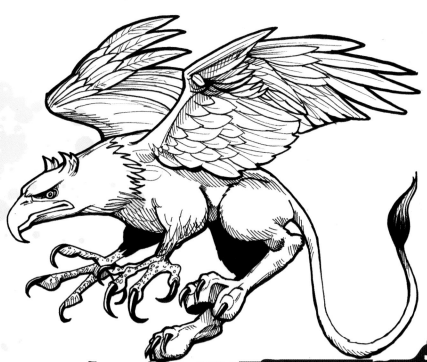

DEMONSTRATION
HYDRA

A deadly serpent from Greek mythology with multiple heads and poisonous breath, the Hydra was the guardian of Lake Lerna, one of the entrances to the Underworld.

THE HYDRA'S ABILITY TO REGENERATE ANY HEADS LOST IN BATTLE LED MANY TO BELIEVE IT WAS INVINCIBLE.

But the hero Heracles was able to kill the beast by cauterizing the neck stump of each severed head to prevent regrowth.

1 Draw a big S-curve connected to smaller S-curves. Sketch the basic shapes of the snake heads at the end of each small S-curve.

COLOR TIPS

Use a variety of greens and grays for the scales. Make sure the underbelly is a light color, and don't forget the glowing yellow eyes!

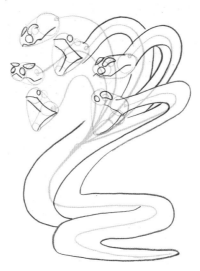

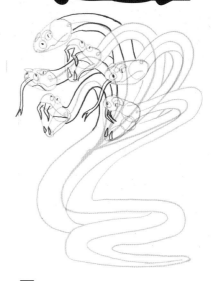

2 Add the basic shapes of the eyes and jaws on the snake heads.

3 Thicken the main body, and build some of the necks. Draw V-shapes for the open mouths.

4 Add long, curved fangs to the open mouths. Draw S-curves for the tongues, and put a little fork at the end of each one. Draw in the rest of the necks, working from front to back. Use a darker pencil for the final neck lines so you don't get confused and accidentally overlap the necks.

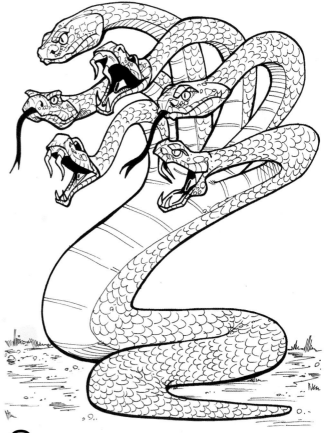

5 Define the Hydra's form by drawing over the lines you want to keep. Erase the lighter guidelines you no longer need.

6 Add the scale patterns and any other details you choose. There is no limit to the amount of heads the Hydra may have, so draw as many heads as you want!

DEMONSTRATION
KRAKEN

The most feared and destructive creature of the sea, **THE KRAKEN HAS BEEN HELD RESPONSIBLE FOR COUNTLESS SUNKEN SHIPS AND THE DEATHS OF MANY SAILORS.** An enormous squid-like creature, the Kraken can take down a clipper ship with one strike of its giant tentacles. Although it lives in legend, some people believe the Kraken still awaits its prey in the unknown depths of the ocean.

COLOR TIPS

Use bright orange for the Kraken's skin, and yellow for its giant eye. Blue tones are good for water, but you can experiment with greens and purples. Make the ship any color you like.

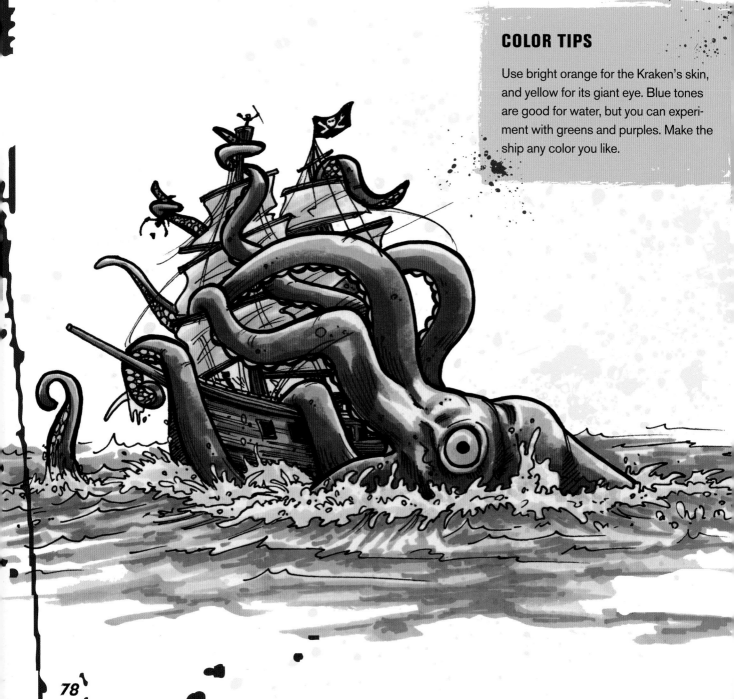

1 Draw a cone shape for the Kraken's body, and sketch some guidelines for the boat.

2 Add squiggly lines to represent the tentacles, and place the eye shape on the head.

3 Build the tentacles, and sketch in some of the smaller shapes on the boat. Draw a couple of lines to represent the surrounding water.

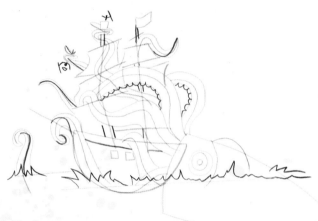
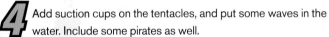

4 Add suction cups on the tentacles, and put some waves in the water. Include some pirates as well.

5 Define the drawing by tracing over the lines you want to keep. Erase the lighter guidelines you no longer need. (You can erase the bottom part of the Kraken's body because it will be hidden under the water.)

6 The Kraken is slimy like a squid or an octopus, so give it a smooth texture. Add small, squiggly lines and jagged peaks to the water to make it look like the Kraken is really making a splash.

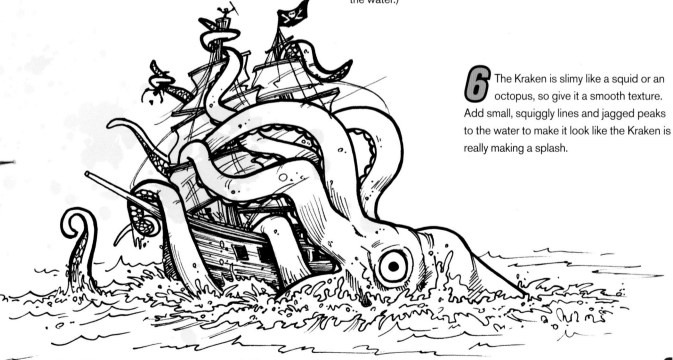

DEMONSTRATION
MEDUSA

Medusa the Gorgon was one of the most terrifying creatures from ancient Greek mythology. She was a woman with snakes for hair and a face so hideous that **ONE LOOK INTO HER EYES WOULD TURN ANY LIVING THING INTO STONE.** Although some believe she was born a monster, the popular myth is that she was once a beautiful maiden who had an affair with the god Poseidon. When the goddess Athena found them together in her temple, she was so offended and outraged that she cursed Medusa, vowing that no man would ever look upon her face again without being turned into stone. Years later, the Greek hero Perseus cut off her head to use her gaze as a weapon. He then gave the head to Athena, who placed it in her shield for eternity.

1 Use an S-curve for the spine, and give a slant to the shoulder line to suggest attitude and seduction. For the head, draw a circle at the top of the S-curve, then draw an egg shape over the circle.

COLOR TIPS

Use lots of greens and browns for the scales, and give a few of the snakes bright underbellies. Make Medusa's eyes bright yellow or even red.

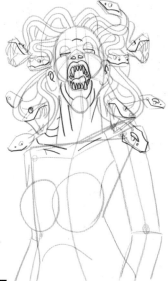

2 Add guidelines to the head for feature placement. Sketch the larger shapes of the hair, using S-curves for the bodies of the snakes, and diamond and triangle shapes for their heads. Build Medusa's body with curves and angular shapes.

3 Refine the hair and facial features. Make the eyes large because they are the source of her power. Refer to the Hydra demonstration on page 77 to finish the snakes.

4 Give Medusa sharp fangs, and finish the details of the snake heads.

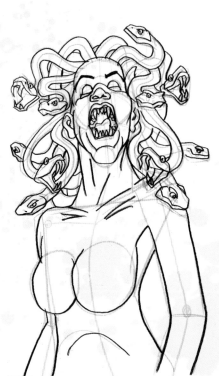

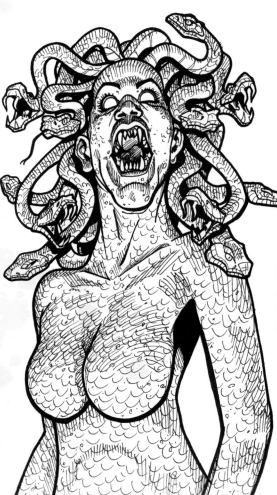

5 Define the shapes by drawing over the lines you want to keep. Erase the lighter guidelines you no longer need.

6 Add final details, such as scales, warts, slime…whatever you want. The uglier the better—just don't look directly into her eyes!

DEMONSTRATION
MINOTAUR

The Minotaur of Greek mythology was a creature that was part man and part bull.

The ghastly beast was born as a punishment for King Minos from the Greek sea god, Poseidon. **THE MINOTAUR GREW TO BECOME FEROCIOUS,** and King Minos had a great labyrinth constructed to hold the creature. He remained there until the Greek hero Theseus hunted and killed him in the labyrinth.

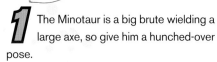

1 The Minotaur is a big brute wielding a large axe, so give him a hunched-over pose.

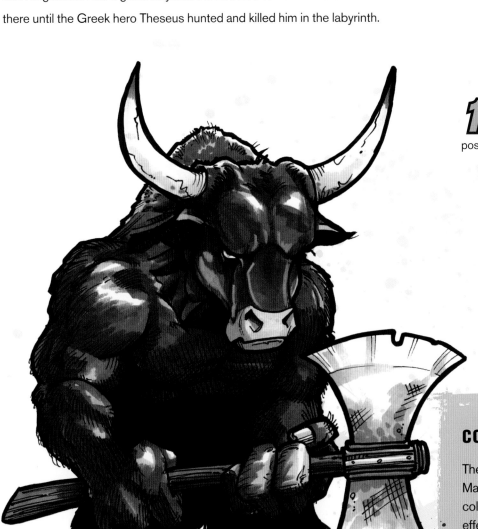

COLOR TIPS

The Minotaur is dark and mostly brown. Make the horns light with bone-like colors. I used a light orange for the rust effect on the axe.

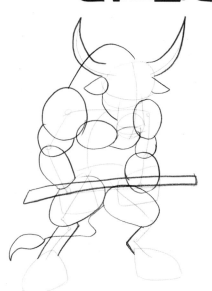

2 Sketch the basic shapes of his bulky body and pointy horns. Don't forget the handle of his axe.

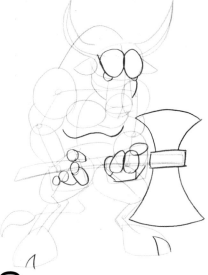

3 Draw smaller shapes that define his features, and add the curved blades of the axe head.

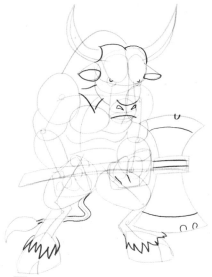

4 Continue defining his features, such as eyes, nose and hooves.

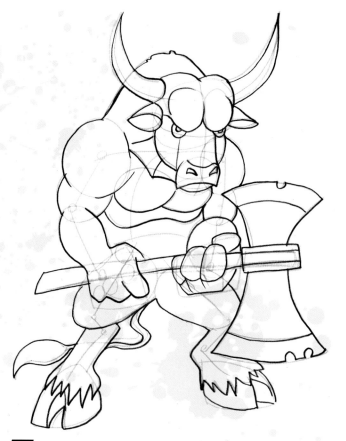

5 Define the creature by drawing over the lines you want to keep. Erase the lighter guidelines you no longer need.

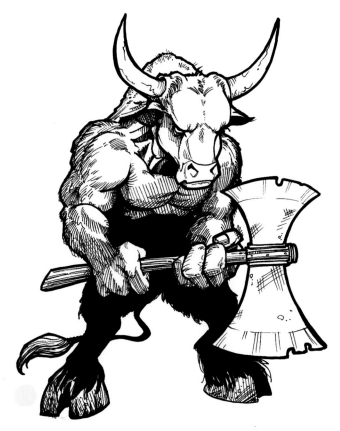

6 The Minotaur is hairy, but not shaggy, so use shorter lines for the shading and texture of his fur. Add some rough texture lines to the axe blade and handle as well.

SEA SERPENT

For as long as mankind has sailed the open sea, there have been legends of giant sea creatures. **ONE OF THE MOST DANGEROUS IS THE SEA SERPENT,** known for its speed and long, coiled body that can pull unsuspecting ships down to the cold depths of the ocean.

COLOR TIPS

Make this creature bright and shiny like a fish. I used blue and purple colors to achieve this look. Give him bright yellow eyes and a red tongue. Use different shades of green and blue for the water.

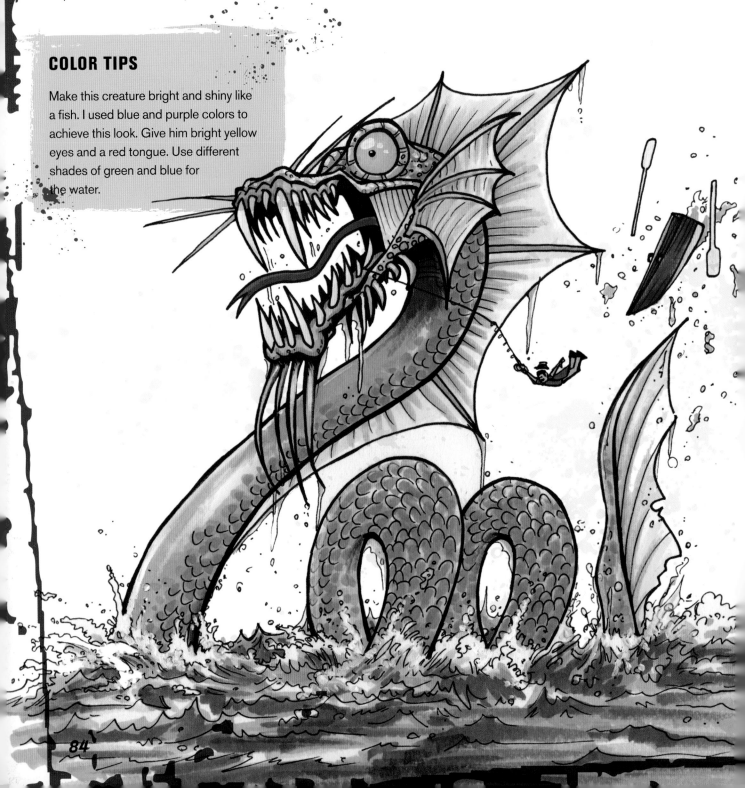

1 Start with an S-curve that has a couple of loops in the middle. For the head, draw a circle at the top of the S-curve, then two smaller circles out in front of that for the nose and mouth area. Connect the circles with a V-shape. Draw a guideline for the ocean water.

2 Follow the S-curve to build the body. Draw circles for the eyes, triangles for the teeth and fin, and a diamond shape at the end of the tail.

3 Draw some lines coming from the head and down the back for the larger fins. Add a few whiskers to the chin, and tighten the facial features.

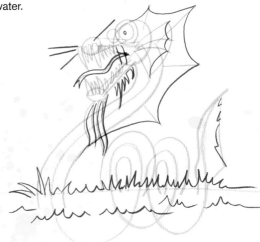

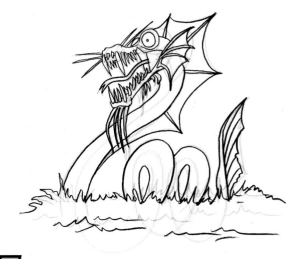

4 Build more whiskers on the face, and connect the straight fin lines with curved lines. Draw the basic shapes of the ocean water, making peaks where the serpent's body is breaking the surface.

5 Define the shapes by drawing over the lines you want to keep. Erase the lighter guidelines you no longer need. (You can erase the parts of the serpent's body that are hidden under the water.)

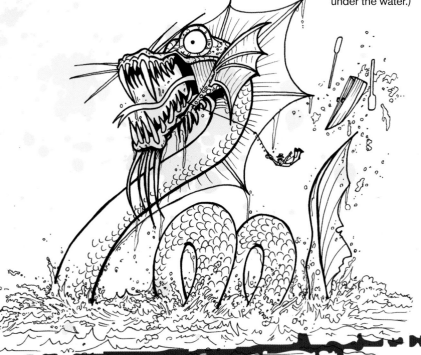

6 Add the final details, such as scales, textured fins and splashing water. You might want to throw a fisherman or boat in there to make the serpent look gigantic.

SPHINX

SPHINXES ARE CREATURES OF GREAT POWER AND WISDOM that originated in ancient Egyptian mythology. They were the guardians of royal tombs and religious temples. The largest and most famous is the Great Sphinx of Giza, which has the body of a lioness and the head of a human. The sphinx image has been incorporated into many other cultures, with varied interpretations. There are sphinxes that have human bodies with the heads of falcons, hawks, rams or other animals.

COLOR TIPS

Use desert colors such as muted golds and sandy browns. The Egyptian head-piece should be bright, shiny gold with blue or purple stripes to signify royalty.

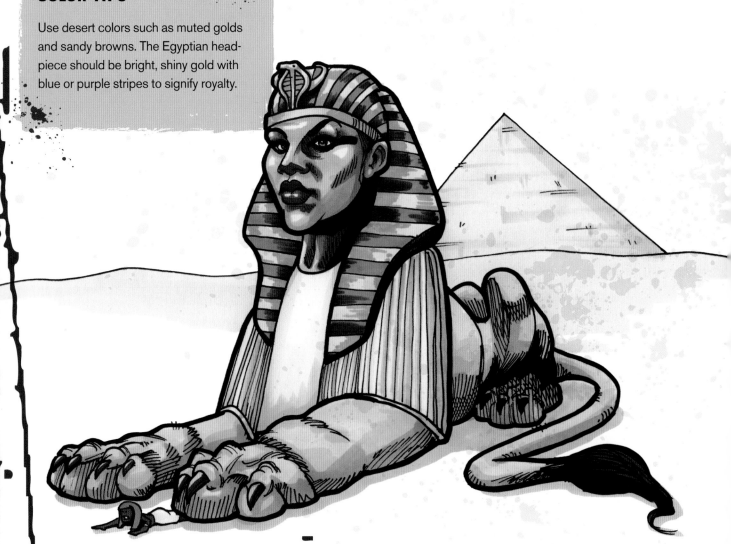

1 The sphinx is lounging in the desert just as a domestic cat would be on your porch. Draw an S-curve for the tail, and don't forget to place guidelines on the head.

2 Sketch the basic shapes of the lion body and the Egyptian headpiece.

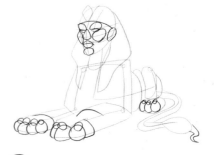

3 Add smaller shapes that define the facial features and paws.

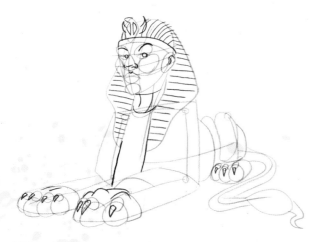

4 Draw some texture lines on the headdress, and define the claws of the lion paws.

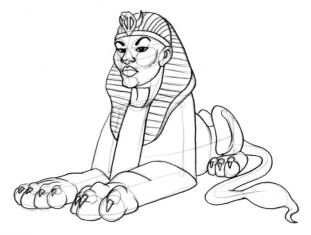

5 Define the shapes by drawing over the lines you want to keep. Erase the lighter guidelines you no longer need.

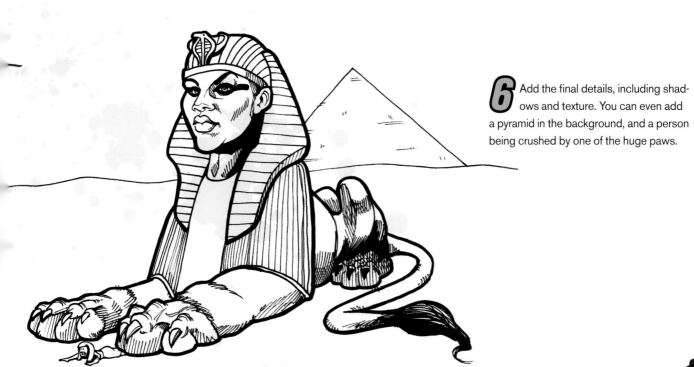

6 Add the final details, including shadows and texture. You can even add a pyramid in the background, and a person being crushed by one of the huge paws.

TROLLS ARE DISGUSTING CREATURES THAT LIVE IN DARK, DINGY PLACES.

They hate sunlight and love to eat small creatures and children. Trolls can hide just about anywhere in nature, but their presence is always evident from their foul smell.

COLOR TIPS

Trolls are really gross, unkempt creatures. Use grays, browns and any other color combinations to create a dirty effect. Give the troll a greenish tongue so it looks sick and slimy.

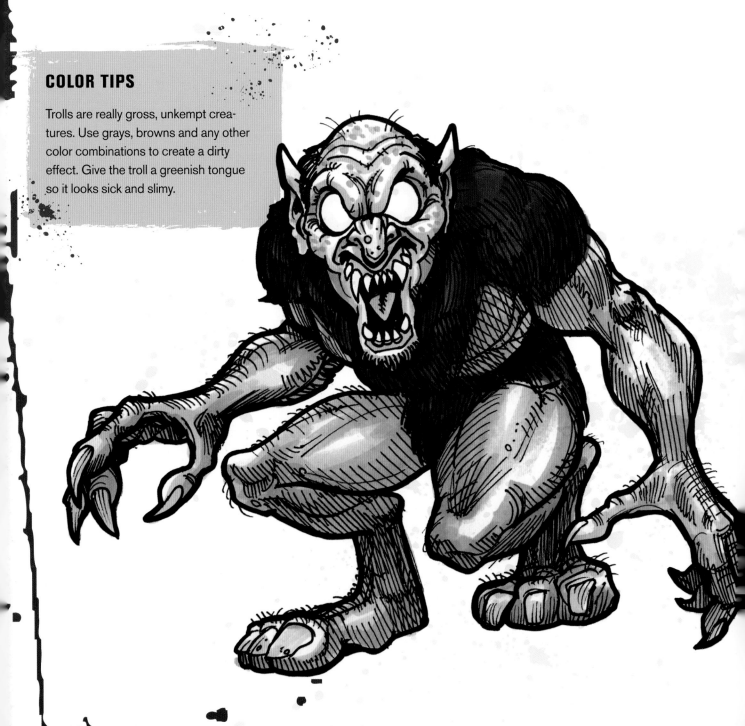

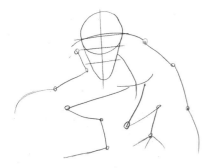

1 Trolls like to hide in dark places as they wait for their prey. Draw this one crouching as if ready to strike.

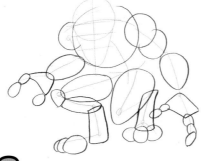

2 Use a lot of circles to build the bulky body and limbs.

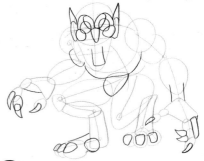

3 Add smaller, tighter shapes to define the claws and facial features.

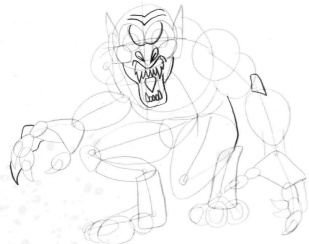

4 Draw lots of jagged teeth and wrinkly brow lines so the troll looks mean.

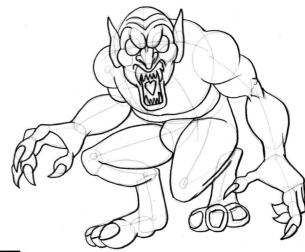

5 Define the troll's form by drawing over the lines you want to keep. Erase the lighter guidelines you no longer need.

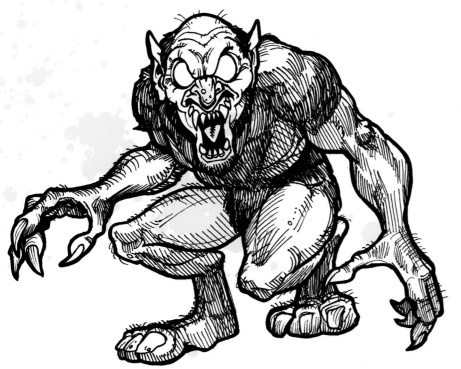

6 Trolls can be really nasty. Some parts of their bodies are covered with hair, while other parts are slimy or mangy or covered with warts. Add as many textures as you want.

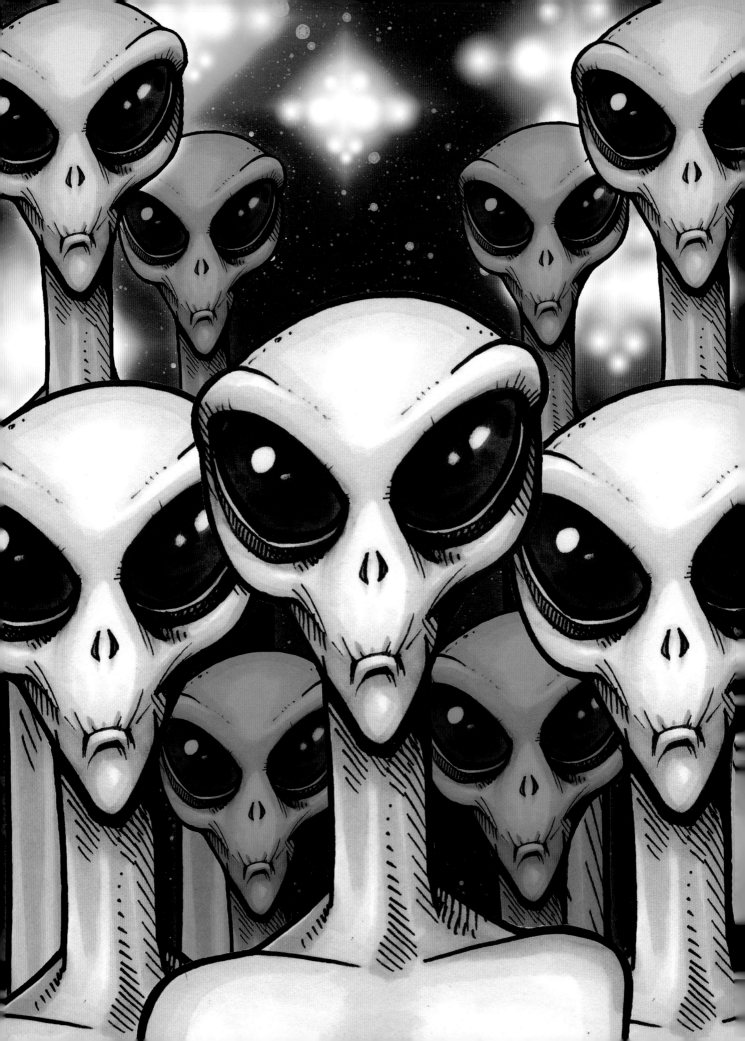

ALIENS & OTHER GALACTIC TRAVELERS

For centuries man has looked at the stars in wonderment. Is the vast universe merely an eternal stretch of stars and planets, or could there perhaps be other life forms beyond our reach? Have we been visited by extraterrestrials? While no official recognition of alien life has been made, many humans believe with all certainty that we are not alone in this universe. What strange creatures wait for us among the stars?

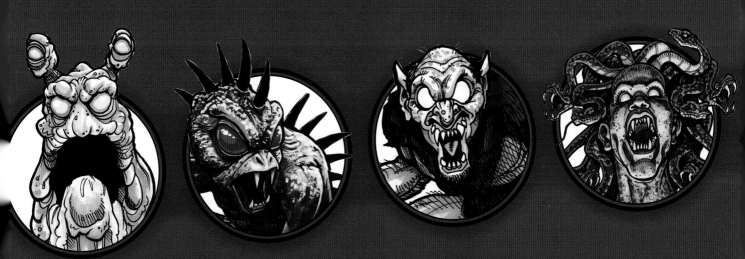

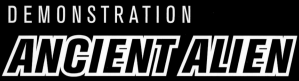

DEMONSTRATION
ANCIENT ALIEN

The Ancients are the **OLDEST AND MOST EVOLVED OF ALL LIV-ING BEINGS IN THE UNIVERSE.** Their philosophy of life is far too simple for any intelligent life form to comprehend, but it is best translated as "harmony."

The Ancients have also been called "Watchers" for their eternal study of everything that is and is not in the universe.

COLOR TIPS

The Ancients are bright white—almost glowing—so use very little color. Whatever color you decide to use for shadows, make it very light.

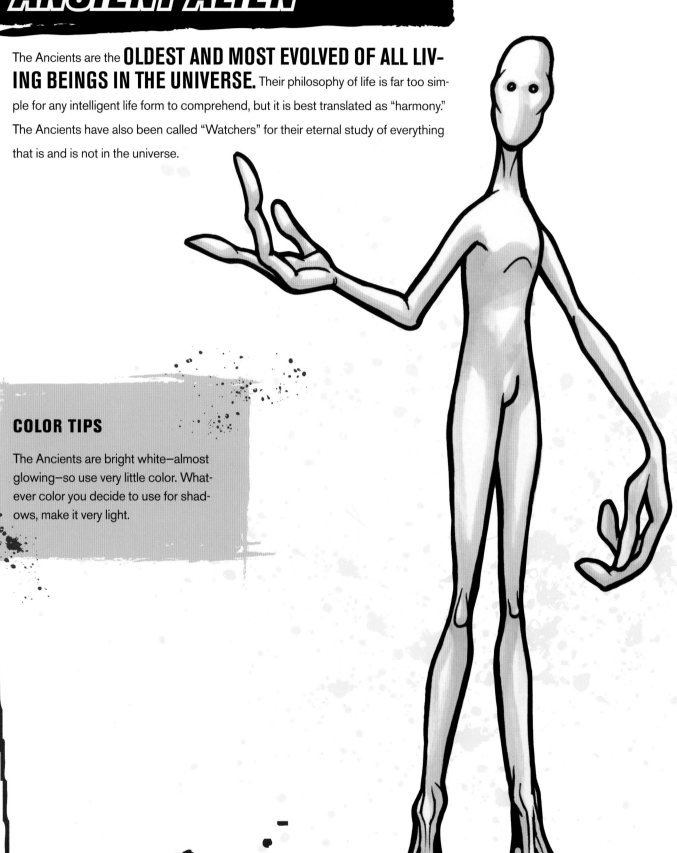

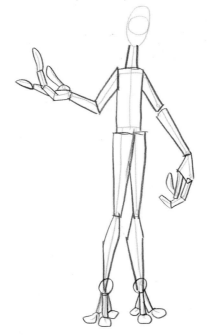

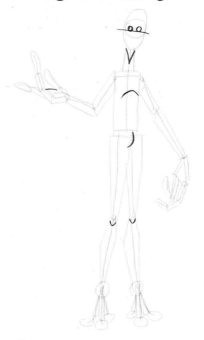

1 Start with an elongated stick figure for this tall, thin alien.

2 Sketch the basic shapes of the body, hands and feet. Keep everything long and thin.

3 Draw small circles for the eyes, and add lines to define some of the shapes.

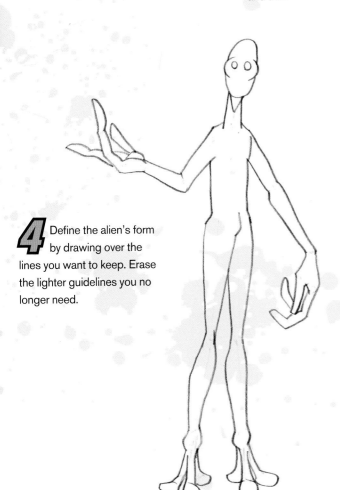

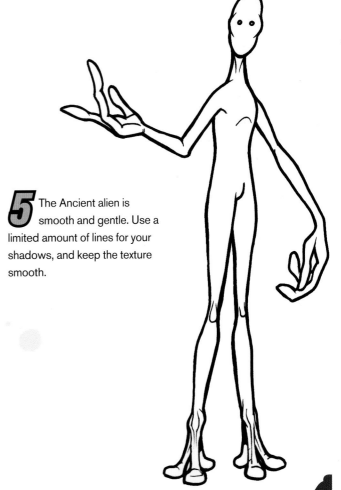

4 Define the alien's form by drawing over the lines you want to keep. Erase the lighter guidelines you no longer need.

5 The Ancient alien is smooth and gentle. Use a limited amount of lines for your shadows, and keep the texture smooth.

BOUNTY HUNTER

Bounty hunters are neither good nor evil. They have no allegiance except to themselves and their paying customers. Known as the best and most brutal hunters of fugitives in the universe, **NO JOB IS TOO TOUGH FOR A BOUNTY HUNTER.**

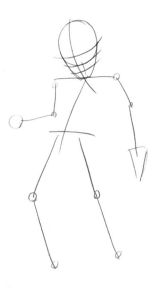

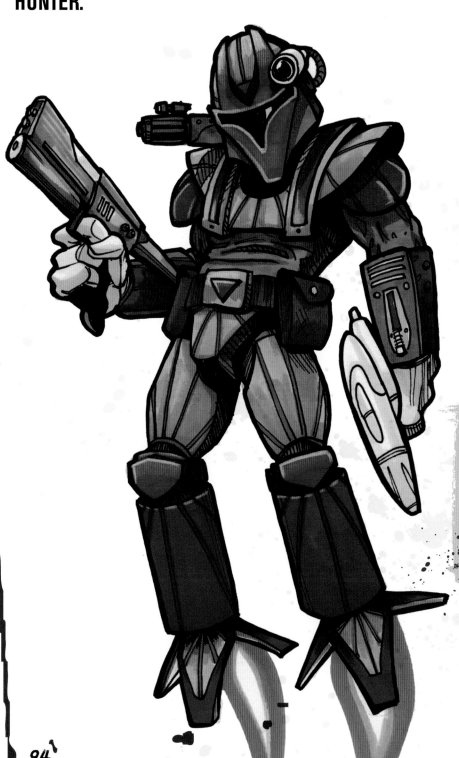

1 Position your stick figure so it looks like it's shooting through space. Bend one of the legs, and leave enough room around the arms for some cool weapons.

COLOR TIPS

The armor is what makes this character cool. You can use whatever colors you like, but reds, oranges and yellows work well for the rocket flames.

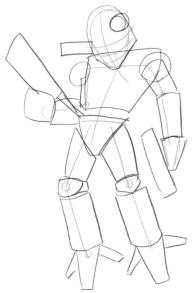

2 Sketch the basic shapes of the body armor, helmet and guns. Keep everything loose for now.

3 Draw smaller, tighter shapes for some of the details on the armor and weapons.

4 Finish adding small details, using lots of lines to give dimension.

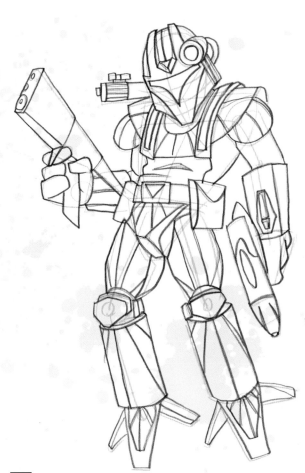

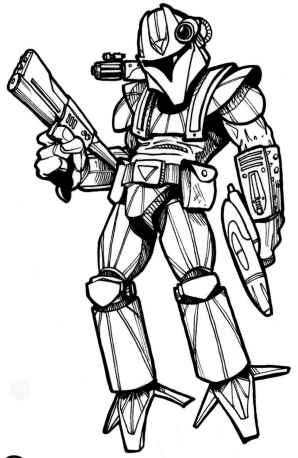

5 Define the shapes by drawing over the lines you want to keep. Erase the lighter guidelines you no longer need.

6 Keep the texture of the armor smooth so it looks shiny. Use bold lines and contrast shadows. If you want, you can make the armor look battle damaged by drawing scratches and scorch marks.

BRAIN ALIEN

SIMPLY A LARGE BRAIN WITH TENTACLES, this alien has the largest cerebral mass of any known living being. Ironically, it is one of the most unintelligent "intelligent life" forms in the universe. Brain aliens feed on dust particles that are absorbed through the suction cups on their long tentacles. They are relatively harmless, but they do have the power to inflict severe headaches on their enemies.

1 Start with a big mushroom-like shape.

COLOR TIPS

The brain should be two different colors to make it look really wild and twisted. I used green for the tentacles, but you can choose any color.

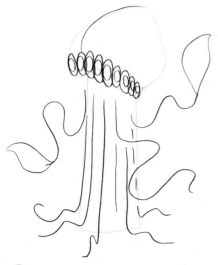

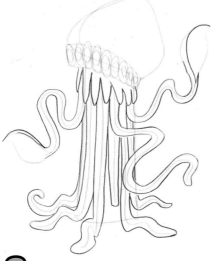

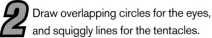

2 Draw overlapping circles for the eyes, and squiggly lines for the tentacles.

3 Build the tentacles as you would a snake (refer to the Hydra demonstration on page 77). Draw some U-shapes to represent the slime dripping from the brain.

4 Draw smaller circles to represent the whites on the eyes, and give the brain some squiggly texture lines. Add crisscrossed lines to the two largest tentacles to help you place their suction cups in a nice pattern.

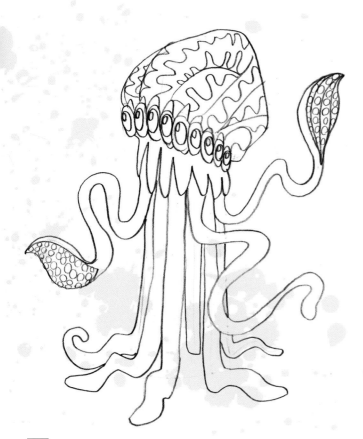

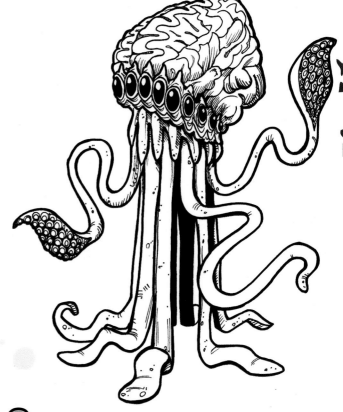

5 Draw over the lines you want to keep, and add the suction cups just as you would scales. Erase any lines you no longer need.

6 Use a lot of soft, rounded lines for textures and shadows to make the alien look slimy and squishy.

DEMONSTRATION
CHUPACABRA

The name chupacabra, Spanish for "goat sucker," comes from a strange phenomenon that began in the 1990s in Puerto Rico and surrounding countries. Cows, chickens, pigs and especially goats started turning up dead and bloodless, with two small puncture wounds on the neck. It was a mystery until **A RANCHER IN TEXAS AWOKE ONE NIGHT AND SAW THE FRIGHTENING CREATURE FEASTING ON ONE OF HIS GOATS.**

Most biologists and wildlife management officials view the chupacabra as an urban legend, but some people believe the creatures are actually a reptilian alien race. Luckily, all they seem to eat is livestock…for now.

1 The chupacabra is known to jump high and hide in trees, so draw it in a crouched position as if ready to pounce.

COLOR TIPS

Use dark greens and browns for the skin. Mine has a camouflage look because the chupacabra likes to hide in dark places and blend into its surroundings. The most important detail is the red eyes—finally, some that aren't yellow!

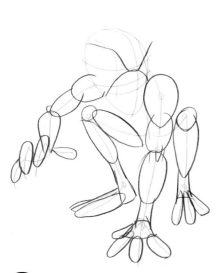

2 Draw loose circular and oval shapes to build the body and limbs.

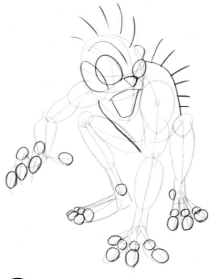

3 Add facial features and tighter shapes for the fingers and toes. Draw simple lines for the spikes along the head and back.

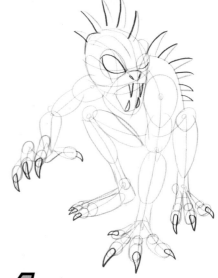

4 Add sharp fangs and claws. Tighten the eyes and nose, and add some dimension to the spikes.

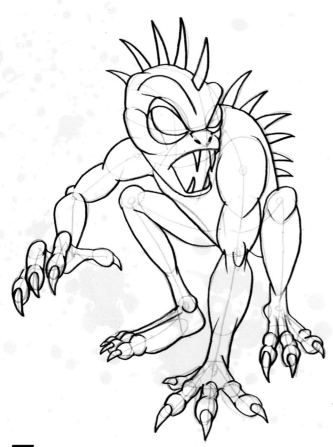

5 Define the creature's form by drawing over the lines you want to keep. Erase the lighter guidelines you no longer need.

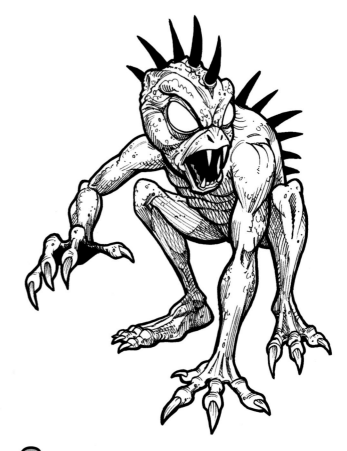

6 Fill in the spikes with black. Add shadows and texture with simple lines to make the skin look bumpy and leathery.

DEMONSTRATION
DINO ALIEN

Dino aliens are some of the **MOST GRACEFUL AND INTELLIGENT BEINGS IN THE UNIVERSE.** They are excellent pilots as well as loyal and very social with all species. Their calm, fun demeanor and beautiful colors demand admiration. Their only enemy is the space slug…but space slugs hate everybody (see page114).

1 The pose of this alien looks complicated, but you can do it if you take your time and focus on the basic shapes. Start with S-curves for the body, tail and hair. Then add the head and limbs.

COLOR TIPS

Use lots of bright colors for this alien's clothes and skin. Make the potion bottle neon green or another wild color so it looks magical and mysterious.

2 Build the basic shapes of the limbs and hair, and add more curves to the tail. Draw a U-shape behind the head as a guideline for placing the small tentacles.

3 Add the smaller shapes for the tentacles, hair, facial features, and the bottle of potion.

4 Define the pupil, and add even smaller details such as a ponytail holder, belt, cuffs, a collar and toes.

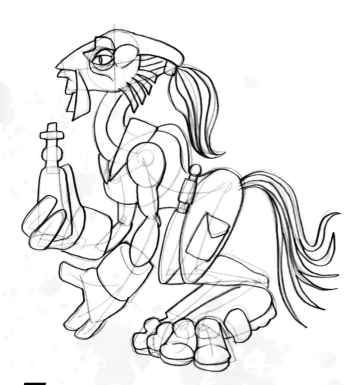

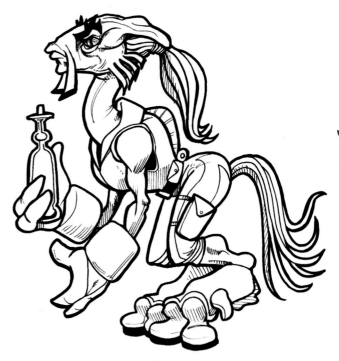

5 Define the shapes by drawing over the lines you want to keep. Erase the lighter guidelines you no longer need.

6 Use smooth, straight lines to give this alien skin that is smooth like rubber. Add shadows and any other details you choose— get creative!

GRAY ALIEN

When speaking of UFOs and extraterrestrials, **NO OTHER SPECIES OF ALIEN IS MORE ICONIC THAN THE LARGE-EYED GRAY ALIEN.** Many people have reported sightings of and encounters with these beings, with strikingly similar descriptions. Some claim to have been abducted and taken aboard the aliens' ships for experiments. Little is known about these aliens or their motivations, but one thing is clear…they are watching!

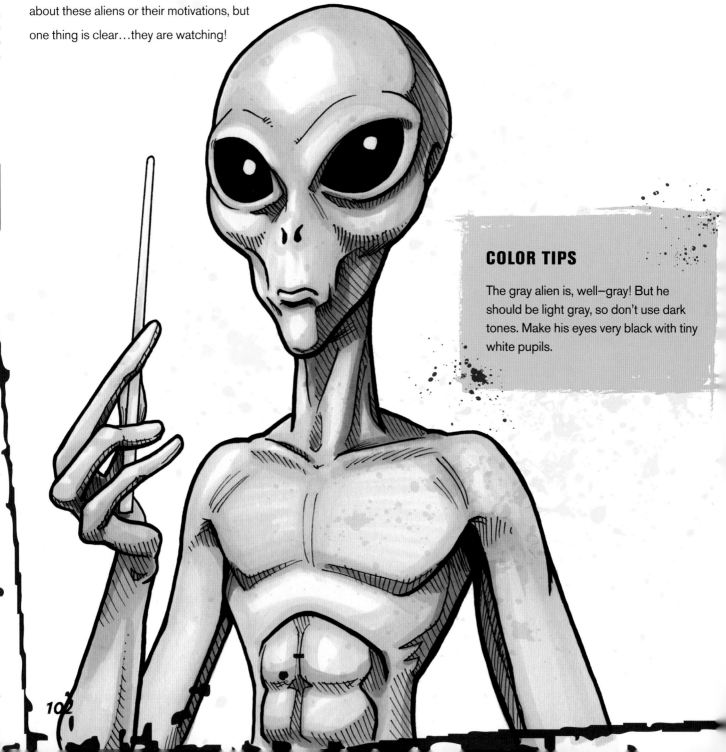

COLOR TIPS

The gray alien is, well—gray! But he should be light gray, so don't use dark tones. Make his eyes very black with tiny white pupils.

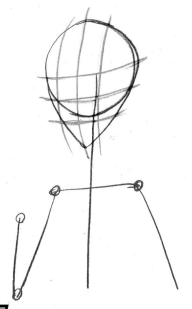

1 Make this alien's head a lot larger than its body.

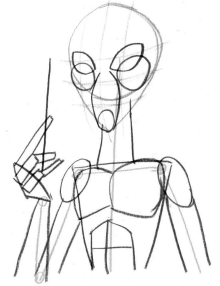

2 Sketch the basic shapes of the body and facial features. Add a line for the wand in the alien's right hand.

3 Add more lines and shapes to define the face and wand.

4 Define the alien's form by drawing over the lines you want to keep. Erase the lighter guidelines you no longer need.

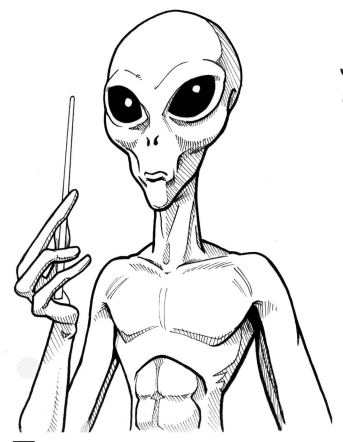

5 This alien's skin is smooth like rubber or plastic, so keep your texture lines smooth and simple. Don't add too many shadows or highlights, because the skin has almost no color.

MARTIAN PILOT

Native to Mars, "the red planet," Martians are generally depicted as small green humanoids, but they have various facial appearances. Some look very human, while others look more like insects. **THE MARTIAN CULTURE IS ANCIENT AND HAS A TECHNOLOGY FAR SUPERIOR TO THAT OF HUMANS.** For unknown reasons, Martians have a deep hatred for "Earthlings" and have made many attempts to invade or destroy the planet Earth. Despite their well-planned attacks, humans have managed to thwart the Martian plots of Earth's destruction.

1 Start with a small stick figure on top of a football shape.

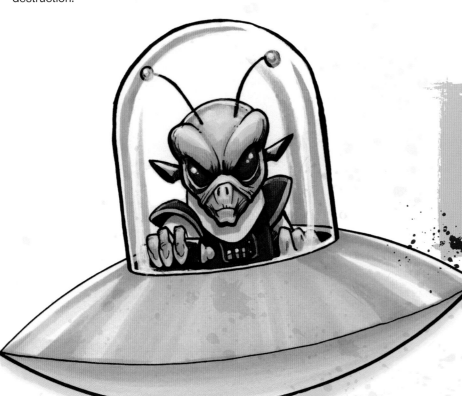

COLOR TIPS

Martians have green skin and red eyes. Make the armor deep red to represent the planet. Use light grays for the silver spaceship, and muted blues for the light beams and the shadows on the capsule.

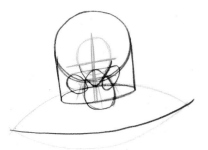
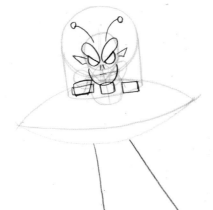
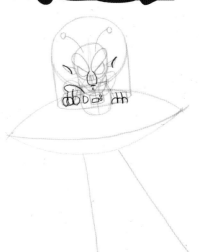

2 Draw the basic shapes of the body, and add guidelines to the head. Then sketch the shapes of the air capsule on the spaceship.

3 Sketch smaller shapes for the Martian's facial features and hands, and give it some antennae. Draw a couple lines to represent light beams coming from the spaceship.

4 Complete the details of the Martian's face and hands.

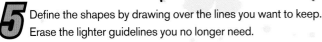

5 Define the shapes by drawing over the lines you want to keep. Erase the lighter guidelines you no longer need.

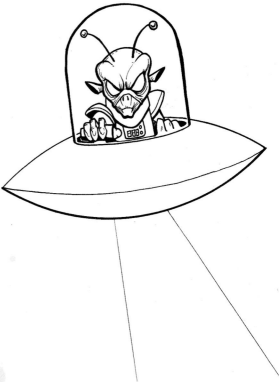

6 The spaceship is metal and glows, so make it light. The Martian has tough, leathery skin and hard metal armor, so you don't need many texture lines. Give him lots of buttons to push!

MARTIAN ROBOT

The Martians used their advanced technology to create robots to do all of their boring jobs—cleaning, cooking and repairing spaceships. But when robots developed the ability to think for themselves, some decided to rebel against their mundane existences. **ORIGINALLY DESIGNED TO HELP, ROBOTS NOW WORK TO HARM.** The Martians gladly use them in their plots against Earth.

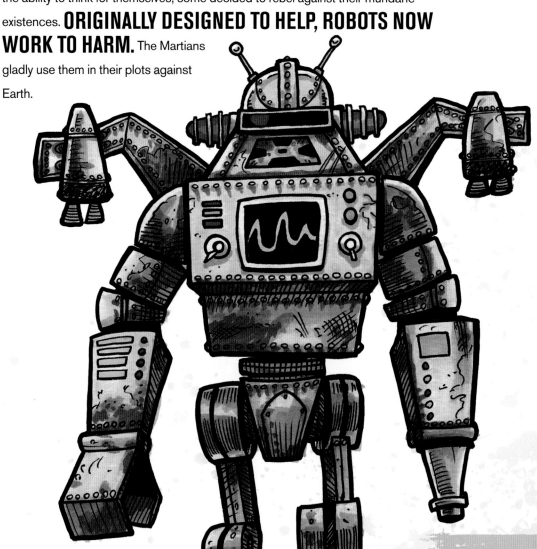

COLOR TIPS

Robots are made of metal so use gray for the body. Use a brownish orange to add the rust. Make the buttons and gadgets stand out by painting them brighter colors such as red, blue and green.

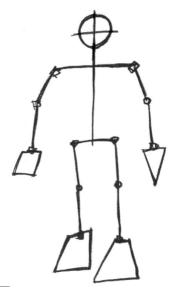

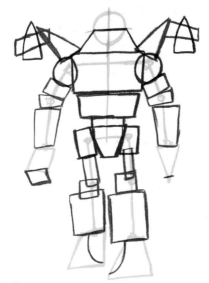

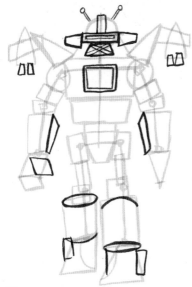

1 Start with a basic stick figure. Draw large shapes for the feet. Its right arm ends with a trapezoid. The left arm ends with a triangle.

2 Use boxy shapes to fill in the body. Make the jet pack behind the shoulders with triangles.

3 Add smaller shapes to define the features and add dimension to the body. The ellipses on the bottom of the legs transform the rectangular area into cylinders.

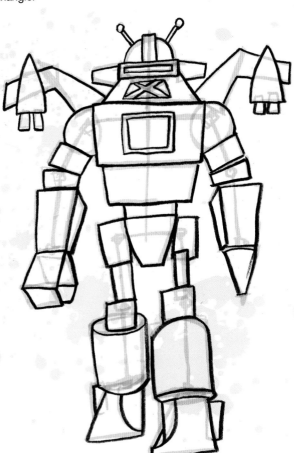

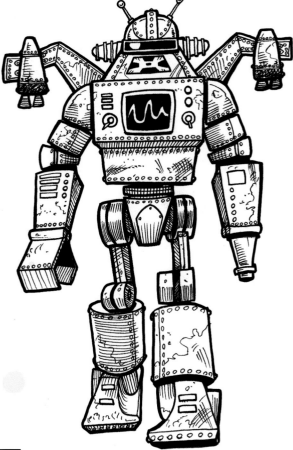

4 Define the shapes by drawing over the lines you want to keep. Erase the lighter guidelines you no longer need.

5 This robot is rusty and old. Add lots of texture so its surface looks scratched and worn. Include bolts so you can see how the robot was put together. Don't forget cool buttons and other gadgets.

DEMONSTRATION
MOTHMAN

On November 12, 1966, a couple from Point Pleasant, West Virginia, was chased by a large creature with red eyes and huge moth-like wings. The Mothman flew after them at speeds exceeding 100 miles (161 km) per hour. Although the couple escaped the attack, **SIGHTINGS OF THE MOTHMAN PERSIST WITH LITTLE KNOWLEDGE OF WHAT THE CREATURE IS OR WHERE IT IS FROM.**

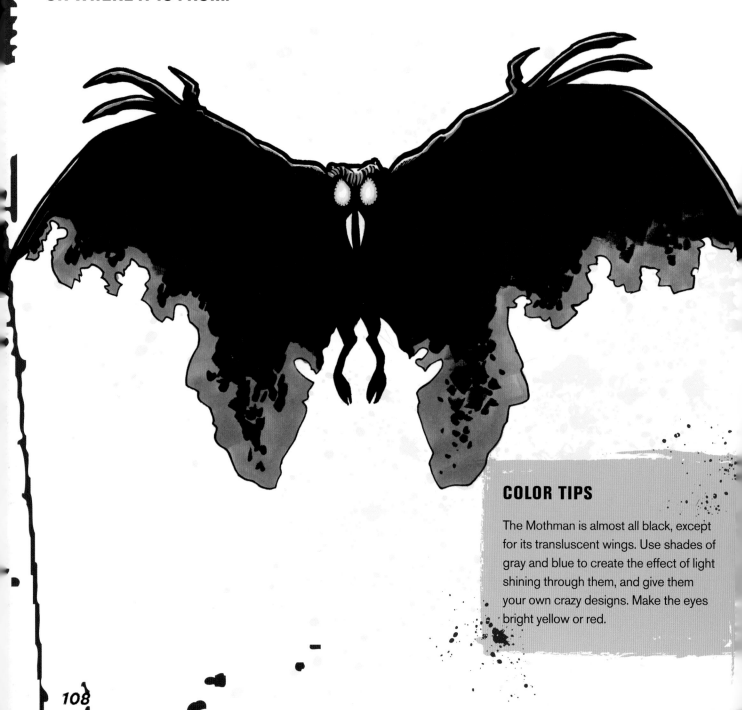

COLOR TIPS

The Mothman is almost all black, except for its transluscent wings. Use shades of gray and blue to create the effect of light shining through them, and give them your own crazy designs. Make the eyes bright yellow or red.

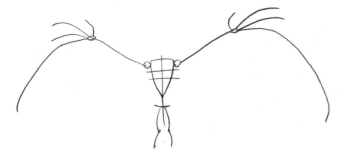

1 The body is small, but the wingspan needs to be wide, so turn your paper longways. Draw lines for the claws at the curved part of each wing.

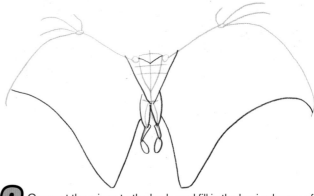

2 Connect the wings to the body, and fill in the basic shapes of the legs.

3 Draw smaller shapes to define the eyes, fangs and claws.

4 Draw some squiggly lines along the edges of the wings to give them a tattered appearance.

5 Define the creature's form by drawing over the lines you want to keep. Erase the lighter guidelines you no longer need.

6 The Mothman's body is very dark, but its wings are translucent like those of a moth or butterfly. Color the body black before you add shadows and texture to the wings, but leave some white areas so you can add blue highlights.

PURPLE PEOPLE EATER

The Purple People Eater is one of the more peculiar alien species. About the size of a bear cub, its appearance is soft, cute and cuddly. But do not be fooled—**THE PURPLE PEOPLE EATER HAS AN INSATIABLE APPETITE FOR HUMANS!** Once it starts to eat, there is no limit to how much it can pack away. It has an even greater love for milkshakes, burgers and 1950s rock 'n' roll, however, so it is wise to avoid drive-in diners.

COLOR TIPS

Give this crazy creature purple fur, pink hands and a shiny black eye. Make the teeth, nails and horn bone-white. Use dark purple for the spots on the fur.

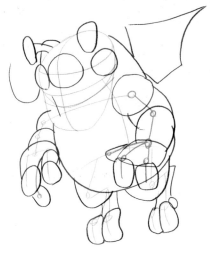

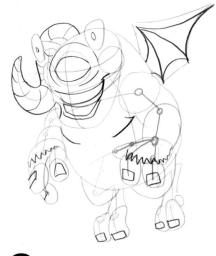

1 Make the head large and boxy, leaving plenty of room for the chunky body.

2 Use lots of round shapes for the body to give it a puffy look. Draw the basic shape of the wing coming out of the alien's back.

3 Add smaller shapes to define the wing, horn, face and nails.

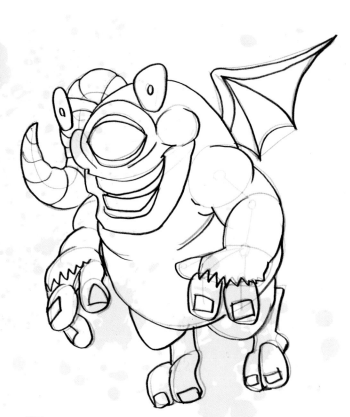

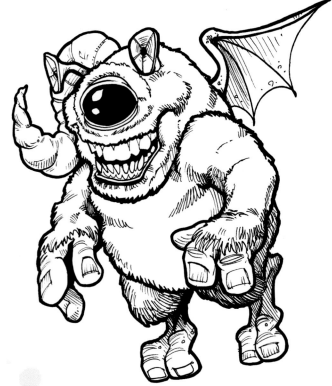

4 Define the shapes by drawing over the lines you want to keep. Erase the lighter guidelines you no longer need.

5 This alien is soft and cuddly like a teddy bear. Give it short, soft-looking fur, but make the horn look hard and bony.

DEMONSTRATION
REPTOID

Reptoids are Earth-dwelling aliens who despise humans. Legend says they have inhabited our planet for millions of years, but that many of them fled Earth when it was struck by a giant asteroid that destroyed the dinosaurs. Supposedly, a small number of Reptoids migrated to somewhere deep below Earth's crust, where they still reside today. Some theories suggest that Reptoids created humans to cultivate the planet while they wait for their chance to repopulate the surface. Reptoids are shape-shifters, which means they have the ability to make themselves look like humans or other creatures. So be careful—**YOU NEVER KNOW WHO MIGHT BE A REPTOID!**

1 Start with a basic stick figure, but make the head big and the fingers extra long.

COLOR TIPS

Use green for the Reptoid's scales, but make the underbelly light like a lizard's. Give the alien yellow eyes.

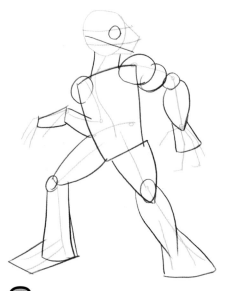

2 Use lots of boxy and curvy shapes for the muscular body.

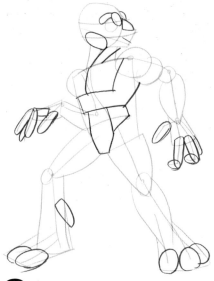

3 Draw smaller shapes to define the face, fingers, toes and muscles.

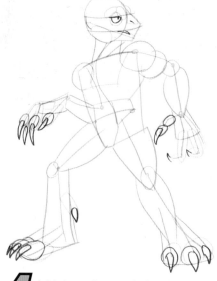

4 Add sharp claws and a beady little eye.

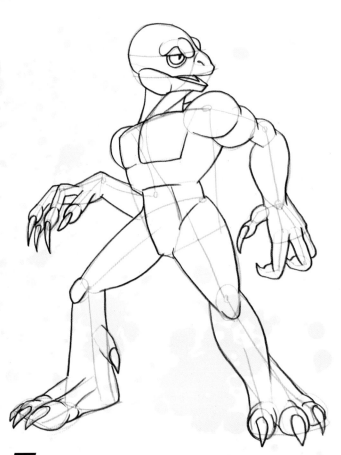

5 Define the Reptoid's form by drawing over the lines you want to keep. Erase the lighter guidelines you no longer need.

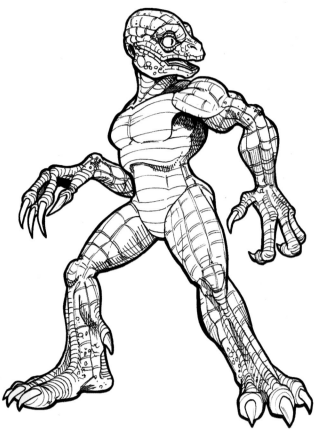

6 The Reptoid is big and intimidating. Use lots of texture lines to make the body look strong and scaly like an alligator. Create a different scale pattern on the belly than on the rest of the body.

DEMONSTRATION
SPACE SLUG

Space slugs are one of the more disgusting creatures found throughout the galaxy. Despite their foul appearance and smell, **SPACE SLUGS ARE VERY POWERFUL AND BRUTAL BEINGS.** They are infamous for ruling the underworld of the entire galaxy with an iron fist...or squish.

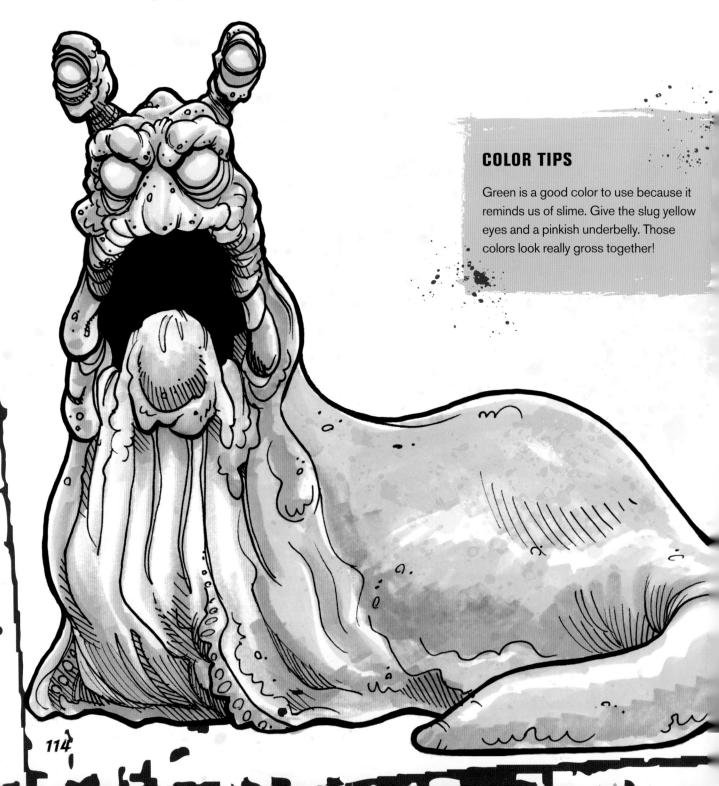

COLOR TIPS

Green is a good color to use because it reminds us of slime. Give the slug yellow eyes and a pinkish underbelly. Those colors look really gross together!

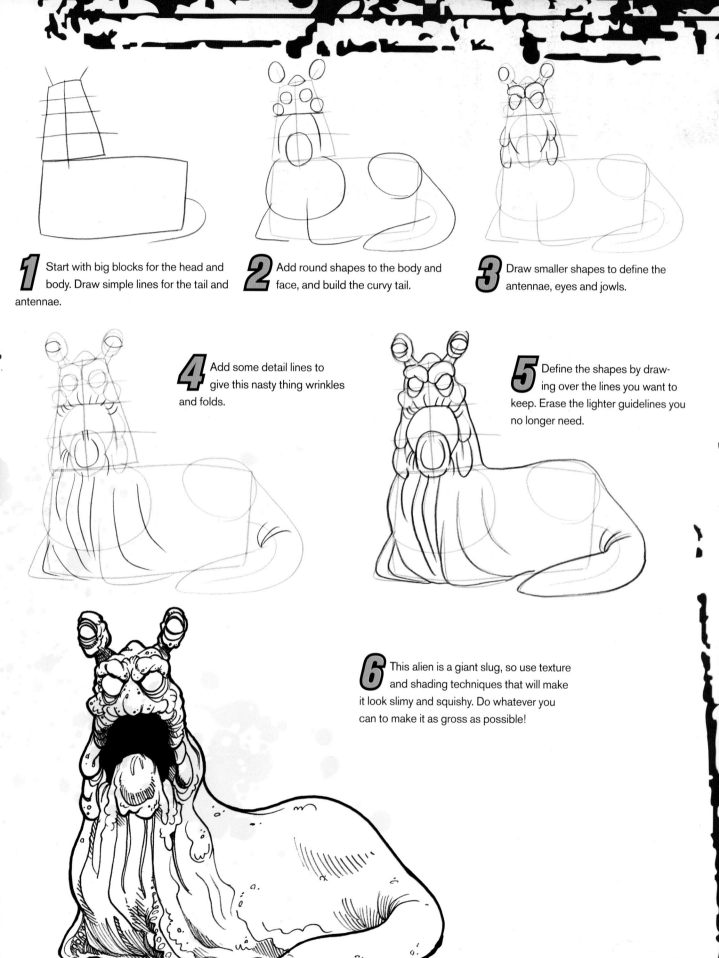

1 Start with big blocks for the head and body. Draw simple lines for the tail and antennae.

2 Add round shapes to the body and face, and build the curvy tail.

3 Draw smaller shapes to define the antennae, eyes and jowls.

4 Add some detail lines to give this nasty thing wrinkles and folds.

5 Define the shapes by drawing over the lines you want to keep. Erase the lighter guidelines you no longer need.

6 This alien is a giant slug, so use texture and shading techniques that will make it look slimy and squishy. Do whatever you can to make it as gross as possible!

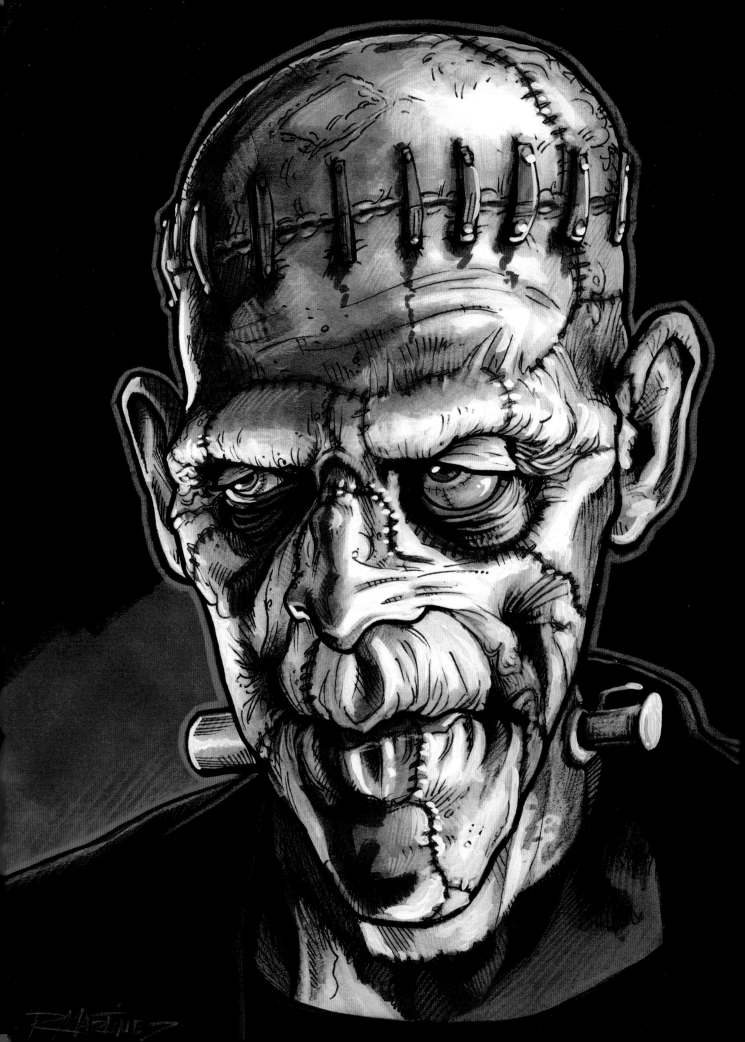

CLOSING WORD

I hope you've enjoyed drawing and learning a few things about these great monsters and aliens. Thank you so much for using my book as a starting point in your artistic journey. But don't stop here! The most important thing you can do is continue drawing.

Second to that, don't limit your subjects to scary beasts and aliens. There are so many interesting things in this world—flowers, trees, cars and, of course, people! The more you learn to draw, the better your art will be.

I encourage you to invent your own creatures as well. Take what you've learned here, and what you see around you, to create some truly scary monsters. You can even write stories about your creations. Who knows? You might have the next legendary monster creeping around in that head of yours!

Now get out there and draw! Until we meet again...BOO!

Sincerely,

RANDY MARTINEZ

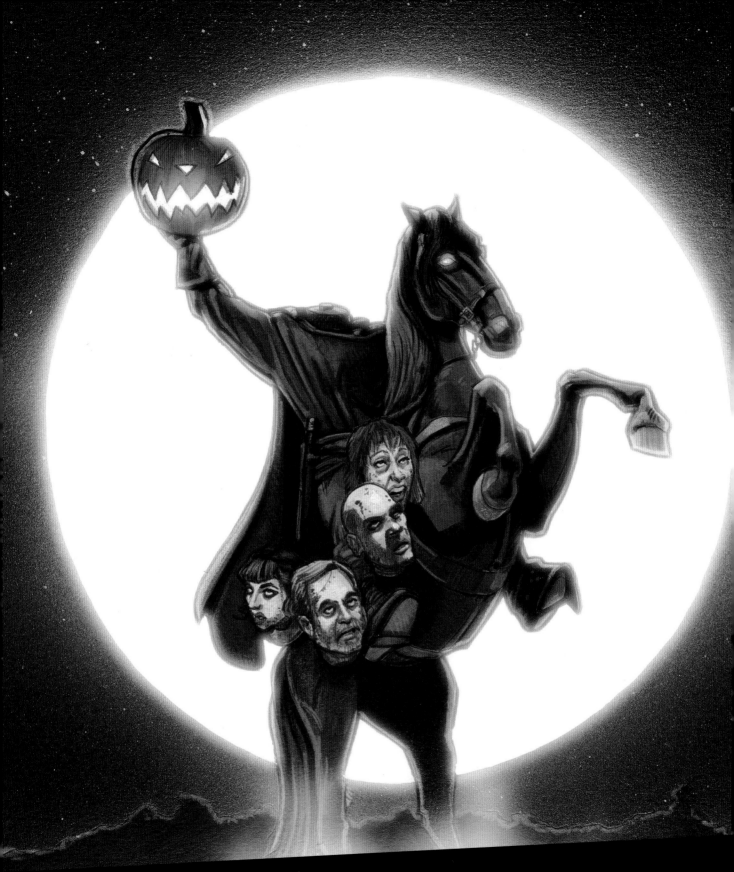

GALLERY

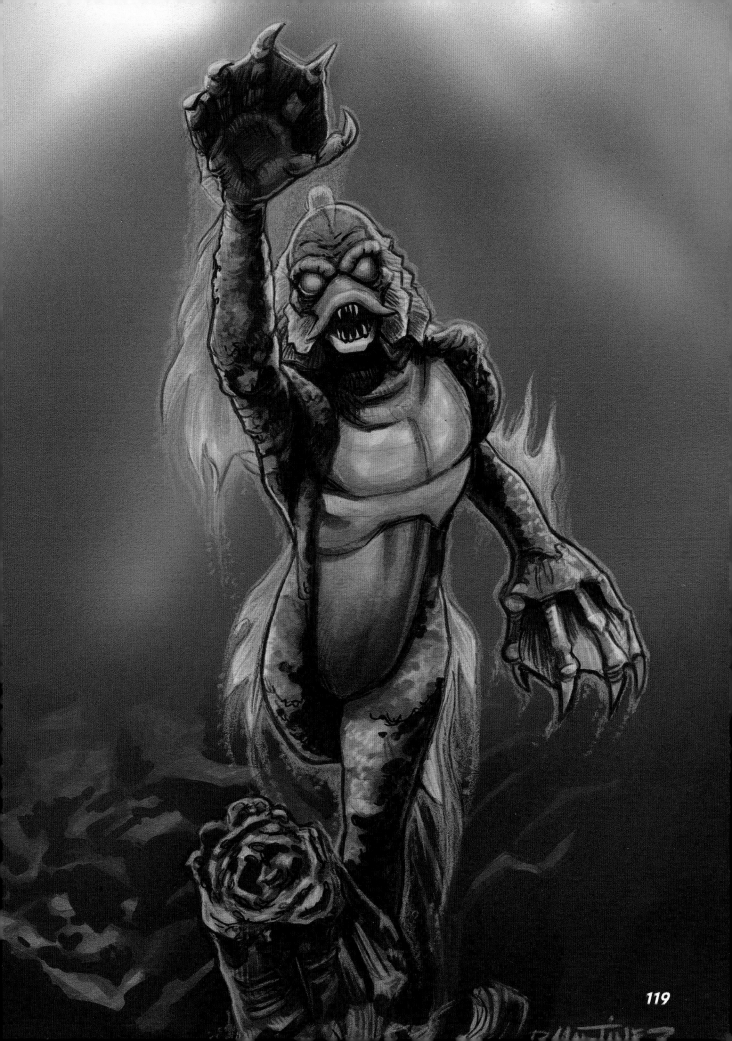

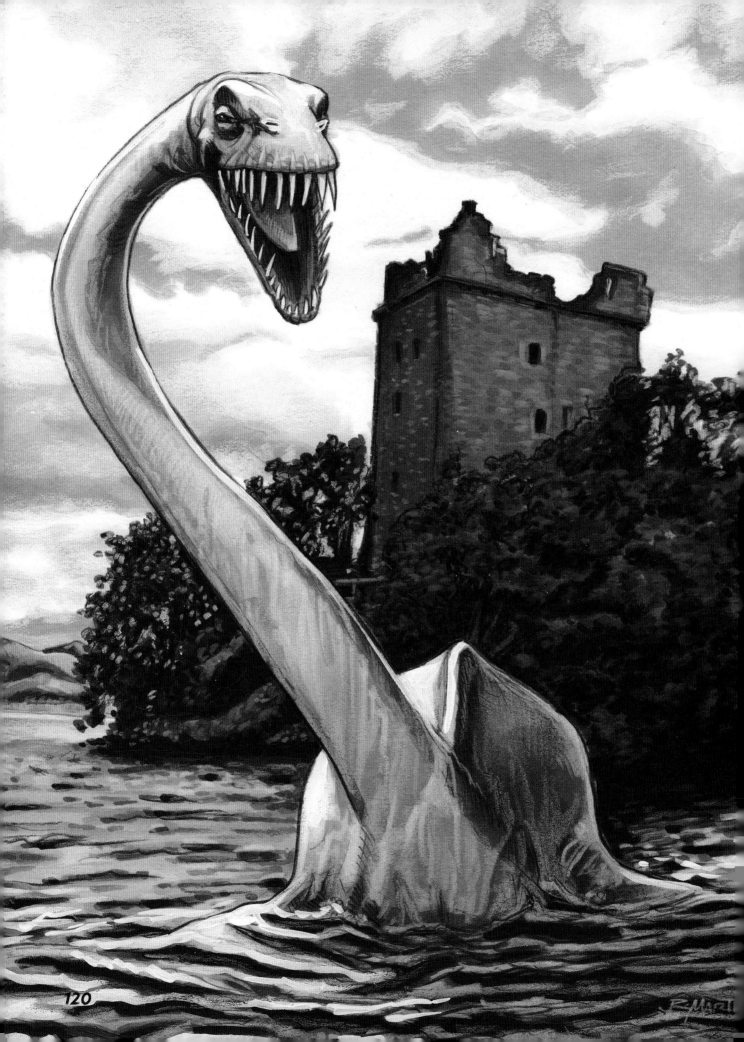

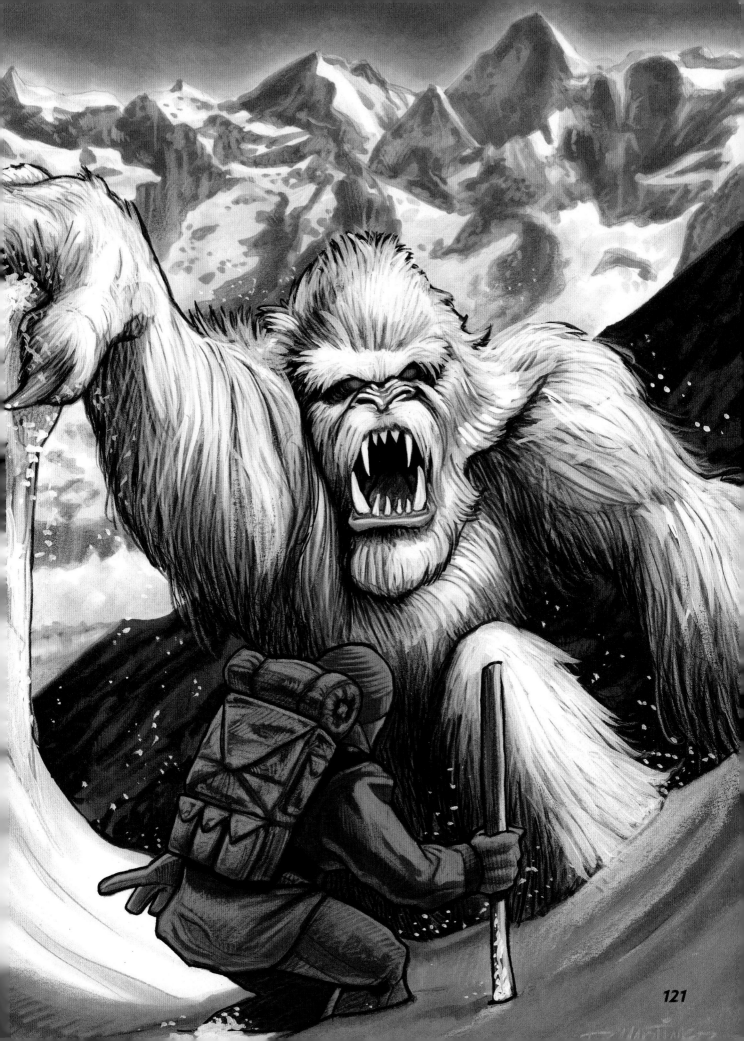

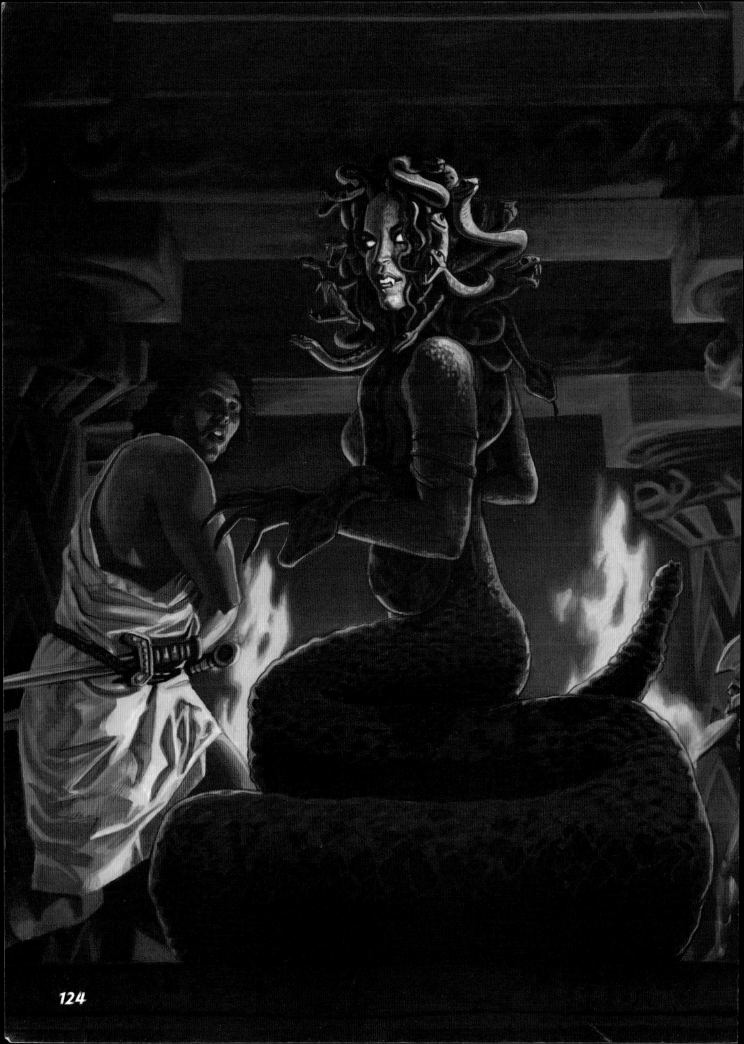

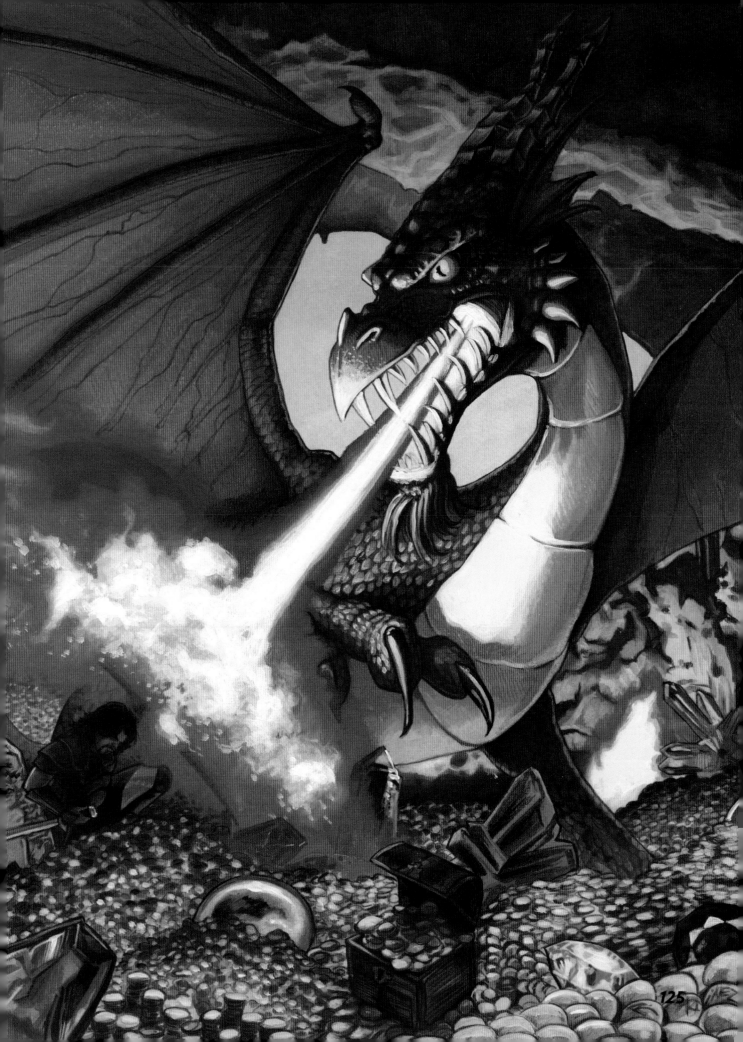

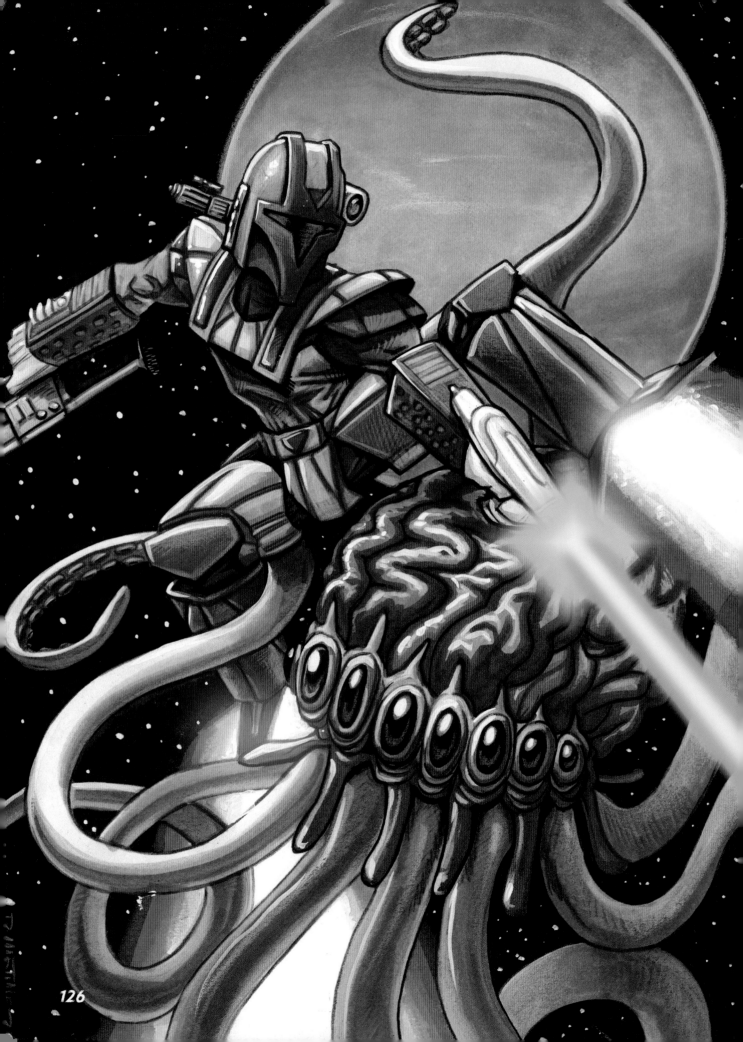

INDEX